STREET
PHOTOGRAPHS

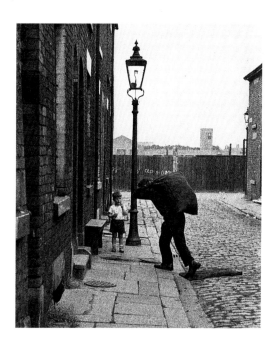

Manchester & Salford

SHIRLEY BAKER 1962
PHOTO BY DENIS BTESH

SHIRLEY BAKER
STREET
PHOTOGRAPHS

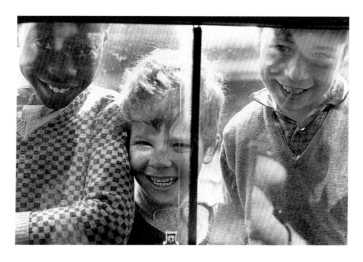

Manchester & Salford

WITH AN INTRODUCTION BY
STEPHEN CONSTANTINE

BLOODAXE BOOKS

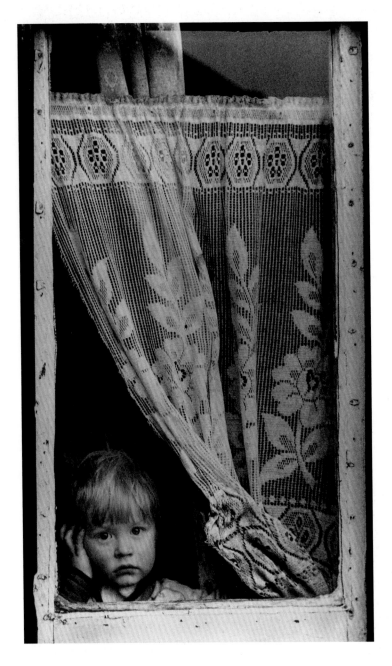

SALFORD 1962

ISBN: 1 85224 058 X

First published 1989 by
Bloodaxe Books Ltd,
P.O. Box 1SN,
Newcastle upon Tyne NE99 1SN.

This book is published with the financial support
of the Arts Council of Great Britain.

Bloodaxe Books Ltd also acknowledges
the financial assistance of Northern Arts.

Typesetting by Bryan Williamson, Manchester.

Printed in Great Britain by
Thetford Press Limited,
London & Norfolk.

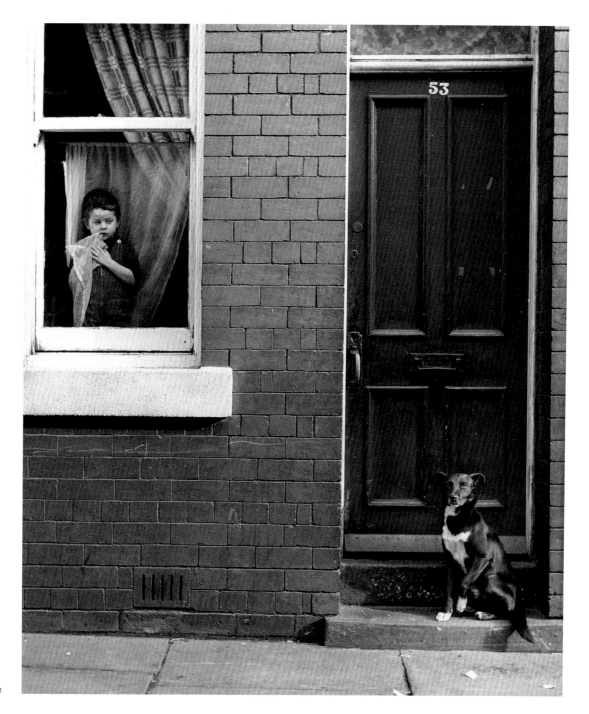

SALFORD 1971

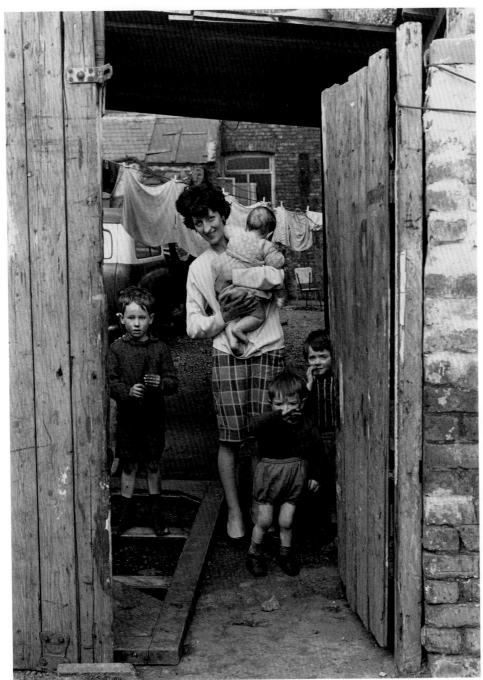

MANCHESTER 1965

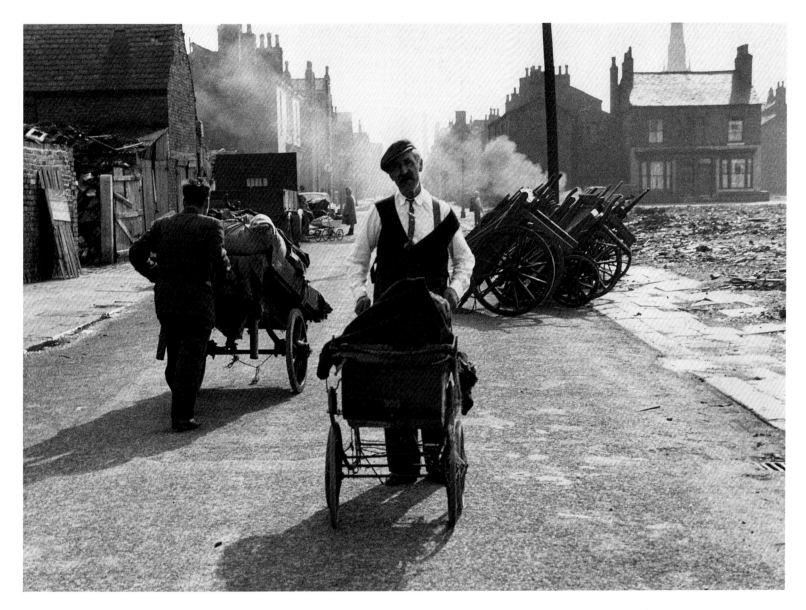

MANCHESTER 1965

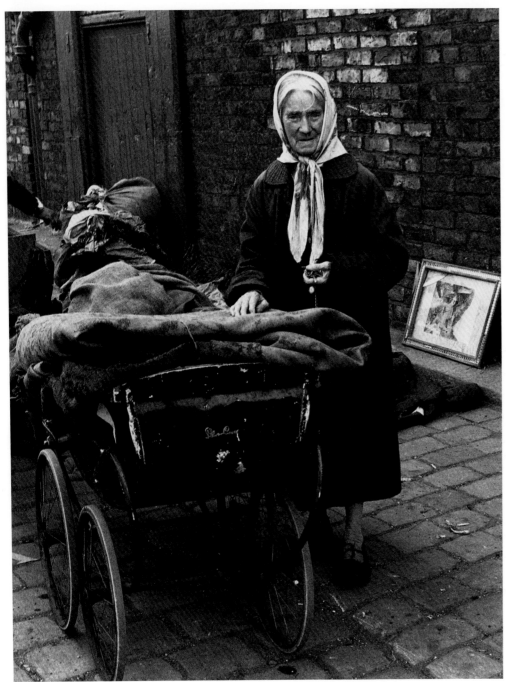

MANCHESTER 1968

Street Scenes: Late Afternoon

Like all photographs, the street photographs of Shirley Baker were taken at a particular time in a particular place, and part of their appeal lies in the preservation of that specific moment. It is late afternoon. Most of the men are elsewhere, still at work, for in these years unemployment was rare, nationally around 1 or 2% of the insured labour force, and paid work was usually available for most of those who sought it. Married women are mainly at home, but they too have been at work and the streets are draped with washing. The elderly are there too, keeping an eye on the children, for the children are home from school and are energetically at play in the streets, tempted out by the sunshine. People talk and smile at the camera, its novel presence causing neither embarrassment nor resentment. There is confidence here and security. But the camera also picks out the exceptions, the lonely child, the conspicuously dirty and ill-dressed, the deprived and defeated.

These photographs were mainly taken between 1960 and 1973, historically a short period, but a time of rapid social, economic and cultural change. It presented working-class families with new challenges, widened their opportunities, offered more rewards and generated much excitement. But it demanded adaptation, challenged the traditional, imposed fresh obligations and ignored the least successful. Benefits passed some by, and there were casualties. The people in these pictures, although living essentially in a 19th-century environment, are recognisably specific to the 1960s and early 1970s, date-stamped by their dress, their hair styles and the toys and impedimenta of the children. Looking back, after a generation, these pictures seem already to reflect a distant past and to have acquired a patina of age, and with it the appeal of history.

We are also looking specifically at the people and street scenes of particular parts of Manchester and Salford. These are the inner city districts, the brickish skirt wrapped tightly around the centre of what Walter Greenwood called the Two Cities: Ancoats, Ardwick, Moss Side, Hulme, Old Trafford, Ordsall, Weaste and Pendleton. A few buildings, particularly churches, now alone remain as landmarks to orientate the present observer.

These photographs must then inevitably capture the imagination and stimulate the memory of those who knew these times and know or knew these places, as they are or as they were. But they have in addition a further importance. The housing stock of towns and cities in all societies passes through cycles of construction, obsolescence, decay, demolition and reconstruction. Elemental forces of wind, wet and gravity get to work on man-made structures. The economically and politically dominant groups in society devise, shape and then remould, if they can, the built environment to suit their changing needs and ambitions. Standards and expectations alter. In Britain there is a long history of urban change and renewal which has largely wiped out the physical structures of the distant past.

The streets and houses in these photographs were constructed at various stages mainly in the second half of the 19th century. Shirley Baker's pictures record their survival in Manchester and Salford into the later 20th century when their moment for demolition arrived, as in other cities. It is late afternoon in the life cycle of a 19th-century built environment. That century had witnessed a remarkable increase in the rate and scale of urbanisation in Britain. In 1801 London was the only city in England with a population of over 100,000, but by 1911 there were thirty-six. In 1801 the urban population formed about 20% of the total and less than 10% lived in a city of over 100,000 people. By 1911 nearly 80% of the population lived in towns and 44% lived in cities of over 100,000. This urban growth took place to satisfy many needs, some of them recreational as

in seaside resorts like Blackpool, Bournemouth and Southend. But mostly towns expanded as industrial, commercial and administrative centres. Industrial needs especially stimulated the rapid population increases and physical extensions of provincial cities like Birmingham, Bradford, Leeds and Liverpool.

Similarly Manchester and its lesser partner across the river, Salford, expanded as one of the wonders of the 19th century. In the early decades it attracted visitors even from overseas to inspect and to react, in admiration or with revulsion. Here was the future. Already in 1801 a substantial conurbation of 84,000 people, Manchester and Salford had together become a mass of some 950,000 by 1911. Here as elsewhere the rapidity of growth was caused by a high and rising rate of natural increase, births exceeding deaths, and by substantial immigration. Migrants came in from surrounding rural areas in Lancashire and neighbouring counties, but also from further afield, from Wales, Scotland, Ireland and continental Europe. (Commonwealth immigration after the Second World War was merely the latest phase in a well-established process.) They were drawn in by jobs in the cotton textile mills, initially concentrated near the city centre, in ancillary bleaching and dyeing industries, in neighbouring coal mines as in Pendleton, in the iron foundries and engineering works, in chemicals, on the railways and canals and later at the docks after the Manchester Ship Canal opened in 1894. Manchester was also a commercial centre, and employment grew in warehousing, retailing and in distribution. In brief, Manchester and Salford like other growing industrial towns offered opportunity and often higher wage rates, albeit with greater risks and social costs.

A growth in employment conjured up a demand for housing to shelter the labour force and their families. This was mainly provided, although rarely at an appropriate pace or quality, by private speculators, often small builders. The value of workers' wages obviously varied according to level of skill, trade prospects, cost of living and size of family, but in the first half of the 19th century few manual workers outside traditional skilled

crafts could initially afford more than low rented accommodation. Moreover, most housing had to be near the works because public transport was for much of the century not available, too expensive or too time-consuming when hours of labour were so long. Accordingly Manchester and Salford like other fast-growing 19th-century provincial cities sucked in labourers and concentrated them in poor quality, high density, ill-equipped accommodation in the inner city districts. Often, like Ancoats and Hulme, they were awkwardly close to the prestigious city centre public buildings, offices and quality shopping streets. Meanwhile, the prosperous middle classes were decamping to the suburbs.

The quality of working-class housing undoubtedly improved as the century progressed. A rise in real incomes allowed higher rents to be paid for superior property, and better public transport, especially the tram, encouraged some dispersal of the population. Moreover, the horrific impact of high density housing on health, and not only working-class health, persuaded local authorities to adopt some controls over the standards of new housing. Local acts banned the construction of further back-to-back housing in Manchester as early as 1844 and of cellar dwellings in 1853. Most of the streets recorded on Shirley Baker's films were constructed under bye-law regulations defined locally in 1867 and strengthened by national legislation in 1875. These determined for developers minimum standards of street widths, room sizes, window areas and sanitation facilities. They guided the erection in many districts of standardised terraces and "tunnel-backs" of two or later three bedrooms with rear passages and back yards laid out in regular grid-iron street patterns. Careful comparison of the photographs will reveal differences in the appearance of streets and house fronts, in the width of road and pavement, in the architectural features of doorways and in the presence or absence of bay windows: such distinctions reflected rent levels and therefore the income, status and aspirations of the families within.

Few of the worst forms of back-to-back houses, cellar dwellings

and fragile terraces survived the condemnation of local sanitary reformers and lasted into the 20th century. Nevertheless, expectations were rising and little had been systematically done by public authorities to eliminate those houses whose methods of construction and facilities were becoming unacceptable. As late as 1951 about one-third of the country's housing stock had been built before 1880, another third in the subsequent years up to 1914. Even in 1961, 22% of households in England and Wales were without a bath or shower, 22% lacked a hot water tap and 13% were without or were sharing a toilet. A significant attack on the slums only began in the 1930s with central government subsidies to assist local authorities tackle the backlog. Manchester's medical officer of health then reckoned there were 70,000 unfit dwellings in the city. Nationally in the 1930s around 245,000 houses were demolished and their inhabitants rehoused. New council estates syphoned off some inner city families to the suburbs, on a large scale at Wythenshawe.

But then Adolf Hitler's Luftwaffe set about random demolition operations, exacerbating a housing shortage which postponed further extensive slum clearance until the mid-1950s. The Housing Act of 1954 and later amendments encouraged local authorities once more to take up the task, and the number of houses demolished in England and Wales rose from around 24,000 in 1955 to between 60,000 and 70,000 a year in the 1960s. The work of destruction raged on until 1973 when the pace rapidly slowed. Pockets of 19th-century housing remained, but altogether some 1.3 million homes were demolished between 1955 and 1975. Families were rehoused, some vertically in high rise flats as in Salford's vast Ellor Street complex, others banished to new semis in distant suburbs like Little Hulton. The combined population of Manchester and Salford had been over 880,000 in 1951, but it had fallen to fewer than 680,000 by 1971. During this period of frenetic activity, recorded in Manchester and Salford by Shirley Baker's photographs, much of Britain's 19th-century urban environment was removed. In the early 1970s its late afternoon moved into twilight.

What was threatened by this process of demolition and urban renewal was not only a built environment but a working-class culture. It was a culture which, like its physical surroundings and partly shaped by them, had grown to maturity by the end of the 19th century to survive substantially intact into the middle of the twentieth. It has been most perceptively described by those brought up within it, especially by the two Salford writers, Walter Greenwood in *Love on the Dole* (1933) and Robert Roberts in *The Classic Slum* (1971). Richard Hoggart in *The Uses of Literacy* (1957) saw its values under threat. Shirley Baker's photographs capture aspects of it, in its late afternoon.

Many of the values and practices of working-class families reflected their sense of vulnerability. Regular satisfactory wages were crucial to family security, health and happiness. From the 1880s most working-class families of medium size could normally manage an adequate though low standard of living, a touch above subsistence, but throughout the decades up to the Second World War there was little to spare between adequacy and deprivation. Unemployment, wage cuts, ill-health, an extra child to feed, old age: such exigencies reduced real earnings, lowered family nutrition and could affect health. Moreover, there were other standards to maintain. To outside observers these acres of working-class housing in the inner cities might appear to contain stereotyped working-class families, but to their inhabitants critical distinctions were recognised denoting respectable and rough areas and families. Respectability and status, the maintenance of dignity against the odds and in the face of adversity, were principal objectives.

The key component in meeting the challenge was the working-class family, ostensibly patriarchal in structure with the masculinity and standing of its head substantially dependent upon his success as a worker and breadwinner. A good husband was a good provider. Family success also depended upon a woman's skills. Beyond her role as mother and social educator of her children lay managerial responsibilities, not least to make the little brought in satisfy a multitude of demands, for rent, for

food, for heat and light, for clothing and for maintaining necessary appearances. While the health of the husband was essential to ensure a satisfactory income, the health or at least staying power of the wife was vital to enable her to manage household tasks satisfactorily. Appropriate duties were also allotted to the children, as errand runners, household job-doers, child minders and, as soon as possible, supplementary earners.

There were also external sources of support to be tapped. Pawnbrokers and the corner shop might provide financial credit, but more wide-reaching were forms of community support. By the end of the 19th century most of these working-class districts were well-settled, and most families found themselves reasonably well-endowed in their areas with kin nearby and long-standing neighbours. Strategies for survival or systems of mutual aid had evolved to help families see each other through such crises of life as sickness, childbirth, sudden death, unemployment and old age.

Such systems depended upon living life publicly. Private lives, more distinctive of more affluent social classes, were in any case difficult to devise in intimate, high density, thin-walled terraces where much social business was inevitably conducted in public places, on the street, in the shop, in the pub. The positive role of the community was obviously coupled to restrictive or negative aspects too. It required a conformity to traditional values, insisted on sexual stereotyping, standardised relations between the generations, discouraged initiative and restricted expectations to those felt normally appropriate for members of a self-conscious but socially conservative working class.

Such features of working-class culture were being eroded by the mid-20th century. Improved educational opportunities provided an outlet for a handful of academically able pupils at secondary schools where horizons were widened, but of greater influence on many more girls and boys were changes in employment opportunities caused by the 20th-century restructuring of the British economy. The older dominant industrial sectors of coal, textiles, shipbuilding, iron working and ancillary dependent manufacturing were in relative decline, and new careers appeared in chemicals, electrical engineering, the motor industry and even more strikingly in transport and white-collar service industries. They demanded new kinds of young workers and widened their expectations. Moreover, working-class real earnings rose, substantially after the Second World War, and unemployment virtually disappeared. Money also went further when the practice of family planning became yet more regular among working-class couples, generating fewer children to feed and clothe. More opportunities for married women to go out to work even appeared, albeit in comparatively low paid, low status and part-time jobs. In sum, most modern working-class families in their 19th-century houses experienced an unprecedented material affluence. In the streets of working-class Manchester and Salford as elsewhere, and in Shirley Baker's photographs, appeared new bicycles and toy prams for the children, always the first to be indulged. Television aerials rose on the roofs of 19th-century terraces, odd anachronisms. Motor cars were parked on the cobbles, thirty years old, very second-hand but a good runner.

Yet although affluence was a solvent of traditional values, raising expectations and limiting the need for mutual support, much of the old street culture survived. Propinquity and common family upbringing preserved traditional mores. A more rapid and near terminal assault came only with slum clearance, redevelopment and re-housing, breaking up neighbourhoods and kin groups. Some working-class families had unilaterally used their new affluence to remove themselves from city centre to suburb, but most inquiries in the 1960s showed families were still anxious to maintain community connections even when expressing their dissatisfaction with the facilities of their houses. Decisions to demolish were not taken, however, by the residents of these districts. Consultation was rare. Control over their own futures was limited. For the most part the poorer working class remained the people to whom things happened, for better or for worse.

The photographs in this book include images of traditional working-class communities in their late afternoon. But they also show us the twilight. The process of planning, compulsory purchase, demolition and clearance was never rapid, even with the best will in the world. The business frequently lasted four years or more. Meanwhile twilight descended on these areas, and darkened neighbouring streets. Many families in affected areas would not wait to be re-housed, but made their own escapes, to the suburbs or often to neighbouring poor property, to be moved on again in the next stage of redevelopment. As houses fell vacant, windows and doors were boarded up, and sites began to be cleared. Defiant and usually elderly residents often remained, under siege from the inexorable plan. The tearing of social ties was almost audible. And meanwhile into soon-to-be-cleared and fast-decaying property moved new immigrants, the least skilled and the lowest paid attracted by minimal rents, or no rents at all in the case of the squatters, who burst into unoccupied houses, and the travellers, who settled on the cleared plots. Frequently these were the rootless, the marginal, the powerless, the ineffective, those overlooked in an age reputedly of affluence and mature welfare services. Final demolition and re-building would tidy away their local presence, moving them over to some neighbouring district. It was appropriate that such deprivation should briefly re-assert itself like a spectre in districts where earlier in the 19th century poverty had often been endemic. Shirley Baker's photographs capture the moment.

This book may also draw from us another response. The artist sees the general in the particular, and we are privileged to observe through her lens. Her pictures direct our gaze to the essential humanity of her subjects, lit up by their unnatural man-made environment. The photographs happen to be of districts of Manchester and Salford in the 1960s and early 1970s, but they represent a more universal phenomenon. In many cities, from Beirut to Belfast, human beings assert their humanity by making families, rearing children and caring for their old people in circumstances rarely of their choosing and not of the best.

The images presented here impress upon us the rough textures of a strictly functional built environment. It is a world of brick and slate, of cobbles and flagstones, of cast iron lamp posts, of churches structured in black Gothic. It is angular, and the tones are grainy, grey, rust-red and soot. When the wind blows we taste the grit. For the most part the sky is a pale overhead presence, save where the bulldozer has ripped down the walls and opened up stark new horizontal perspectives. And within this context, Shirley Baker sees the people, her essential subject. If they can, they impose themselves upon their environment, override it, mould it to their use. They soften its roughness with their forms. The women in conversation in the doorways, the old men in the streets, the children with their innocent vitality, and even the dogs, which Lowry too immortalised, dominate the scene. The people have now moved on. They deserved better, and we may wonder if they found it.

STEPHEN CONSTANTINE
University of Lancaster

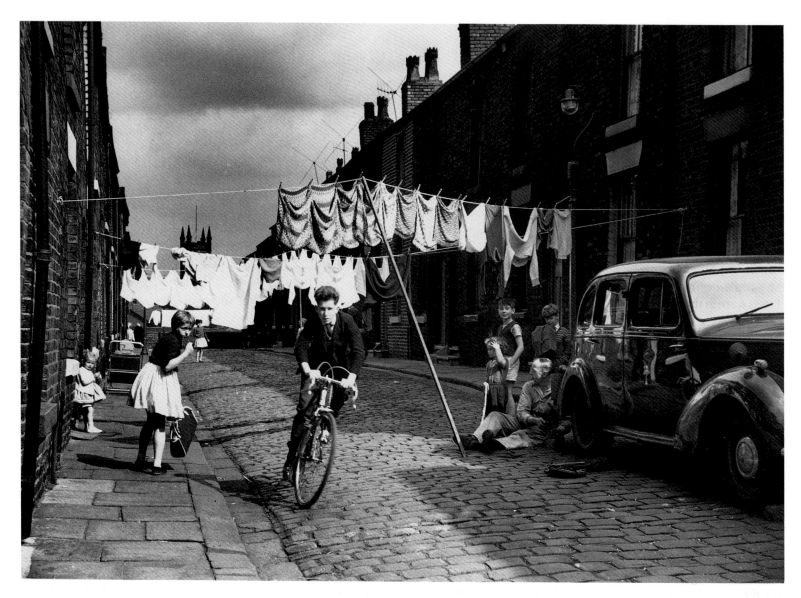

14 SALFORD 1962

Street Photographs

It's strange how, as a child, I clearly remember the thrill of developing my first black and white film in the darkness of a coal shed, yet I can't remember how, years later, the idea came to me to make a photographic record of Manchester and Salford.

I did know that fundamental changes were taking place when I started to take these street photographs at the beginning of the sixties. Homes were being demolished and families were being uprooted – due to a huge "slum" clearance programme – and nobody seemed to be interested in recording the face of the people or anything about their lives. Though many of the streets were in the last stages of decay when I came to photograph them, others were not yet ripe for demolition, so I'm glad that I was able to capture some of the street life as it had been for generations before the change. However, I was inevitably caught up with the clearance programme and the life of the time.

Now the old streets are no longer there and many of the people have gone. The areas have since been built up again to form a new environment with an entirely different character. Some of the people returned, but I often wonder where the others went to – how their lives have changed – and whether they are better off and healthier now than before the great upheaval.

My interest grew into a compulsion even though the notion of someone wandering the unpicturesque streets of Manchester and Salford with a camera seemed quite crazy to most people then. Some of the photographs have been published in newspapers and magazines and others used for publicity purposes but the majority were pushed to the back of a cupboard for many years until I decided to take them out and look at them again. I spread them out on the floor and was immediately overwhelmed by the feeling of rushing back through time and being amongst the people again. I felt then that others might be interested in the pictures and might also share my feelings.

I took the photographs to Audrey Linkman, whose work with Caroline Warhurst at the Documentary Photography Archive in Manchester I had admired for a long time, and, as a result of that meeting, the pictures were shown to the public for the first time in the DPA touring exhibition *Here Yesterday, and Gone Today* at Salford Art Gallery in 1986.

There's no doubt that Salford had some of the worst housing in the country with much of its development dating from the Industrial Revolution. Subgrade dwellings were closely built and sandwiched between factories and workshops. Schools were on dreary enclosed sites, and there were few open spaces. Hardly any land was available to build modern factories and, for economic reasons, it was difficult to knock down the old ones that had already been enlarged and partly modernised. The position of roads, railways and canals also had to be considered – adding to the planners' difficulties. After the war, the city council planned to clear dwellings that were over-age and replace them with modern development.

As sites were cleared, high blocks were built to cut down the population loss as far as possible and planners hoped that the provision of modern development with library, banks, pubs and a shopping precinct would form the basis for a better city with new life.

In Manchester, there was rarely enough room for more than one dwelling house for every two that had to be demolished, so many of the people had to move to areas outside the city. But tenants had to hold the right kind of job to move to a new town. Many were prevented from going to the areas of their choice and others refused over and over again to take up the places

that were offered to them by the council. Manchester also lost many fights over new towns because Cheshire commuters disliked the idea of having working-class overspill estates near to their homes. Progress in the fifties was extremely slow, not only because of these difficulties, but also because the Town Hall planning department was understaffed and could not deal quickly enough with the problems. However, by 1965, there were plans for a slum clearance drive to demolish the remaining 54,000 houses in ten years.

The re-development of Hulme was one of the biggest and most ambitious slum clearance schemes in Europe. After demolition there were more than 3000 acres on which to build. But by 1965 Hulme was dirty, derelict and dreadfully noisy. Rows of houses were marked with an X and people sat miserably on doorsteps of houses that had been condemned. Living conditions for those remaining tenants were appalling; rotten timber from the inner structure of the houses was burned and the air was thick with smoke from the fires and dust from crumbling brickwork which crashed to the ground. Slates were removed from roofs, one by one, to be slid down planks and dumped with other rubbish into lorries, so that there was a constant racket throughout the day. Unwanted leavings, such as old sofas and beds, as well as wrecked cars, littered the streets and open spaces. The area was devastated and looked like a huge blitzed site. However, the children saw things differently – to them it was a giant adventure playground with untold treasure hidden amongst the junk and rubble.

The planners had an impossible task – how could they re-house many of the original population in the same area, yet at the same time create space and leave room to breathe? It was thought then that if blocks of flats were built with inner walkways, sufficient space could be left for playgrounds and recreation areas where trees and grass could be planted. With hindsight, we know that these were not the answers at all.

Living standards had fallen well below the level that was acceptable in a well-to-do society but, sadly, there was no exchange of ideas between the council and householders, many of whom had little understanding of the reasons for change. Those at the "Town 'all" were considered to be spies and the arch enemy of the people who resented having to leave their homes and move away from families and friends.

My sympathies lay with the people who were forced to exist miserably, often for months on end – sometimes years, whilst demolition went on all around them – and the planners who were faced with the truly immense task of creating new cities out of old, with all the attendant difficulties. Many, many mistakes were made, but now we must look hard at the past to learn for the future.

Dire poverty was widespread in the clearance areas – often compounded by ignorance. Families and single parents were trying to bring up children, unaware that they were entitled to any social security benefits. Mothers had to do something to buy food, so toddlers and babies were left in the charge of very young children during the day – some of the very young wandered the streets without any apparent supervision at all. Later, a campaign was mounted to inform the public of their rights. Claim forms were simplified and those who were destitute were encouraged to apply for help.

How easy it is now to look back with nostalgia to the community life and the quaintness of the "good old days" but it is just as easy to forget the other side of the coin – the leaking roofs, running taps, the mould on the walls, the smell of rows of outside lavatories, the fact that there was no hot water and no baths in the houses, and the many discomforts associated with a lack of amenities that are taken so much for granted today. Now, there is talk about psychiatric problems associated with the new estates and high rise flats. I have no doubt that they exist, but I would argue that there were as many problems due to poverty and deprivation in pre-demolition days – as there are today – but few people then had ever heard the term "psychiatrist" and even fewer would have known where to find one. The problems were certainly there – they were simply not recorded.

First of all, I went to Salford to take photographs. I roamed streets on both sides of Regent Road and areas around Hankinson Street, Ordsall and the docks. I suppose most of the photographs were taken within a radius of one and a half miles. In Manchester, I spent much of my time in streets on both sides of Upper Brook Street, near Oxford Road and All Saints – at the back of the university – and in Hulme and Moss Side. The camera alone was my notebook but I regret now that without written notes I am unable to name people or many of the streets. I hope that the pictures in some way speak for themselves, but nevertheless, I apologise for these omissions.

The areas were blighted but there was a lot of good humour about in Manchester and Salford. Many of the houses not yet due for demolition were extremely well-kept with fresh lace curtains and ornaments clearly visible through sparkling windows from the street. Front steps were scrubbed and whitened and even sections of pavement directly outside the front doors were kept in the same pristine condition.

However, just one or two streets away, one end of a terrace was being torn down, even while the other end was still occupied. Immediately a family was evicted – sometimes before – the neighbourhood children arrived to start the demolition process. Their aim was to smash every pane of glass in the house to smithereens before the official demolition gangs moved in. Vandalism was a great sport and to counter attempts to demolish their property prematurely, householders would prominently display notices in their windows to indicate that the houses were still occupied.

Rows of houses were systematically flattened, but the pub, the corner shop – with dwindling customers – and the doctor's surgery were always the last to go. These were usually left standing in grand isolation like odd last skittles after most in the row had been bowled over.

Pets were not allowed in new council flats and, though there may have been good reasons for the rule, it seemed cruel and inhumane and did nothing to improve relations between the council and the public. The result was that dogs and cats were abandoned by their owners and they roamed the streets living on whatever they could forage from the tips, and on scraps put out by sympathetic tenants who had not yet been evicted.

When evicted families moved out, squatters and vagrants moved into their vacated and, by then, vandalised homes. Anything with a roof would do for these poor unfortunates – who only hoped to shelter for a few days before the demolition men finally came with their swinging lead balls, axes, hammers and bulldozers to flatten and sweep away their temporary havens.

After the houses had gone, travelling tinkers trundled their broken-down wagons and caravans on to the empty sites. The men set about their tinkering jobs and the women cooked, whilst their unkempt children played happily amongst the twisted metal and broken glass. Eventually, they too were evicted, too often with more than a little acrimony and some not too gentle persuasion by the police.

For a pittance, men with handcarts and prams combed the ravaged sites, searching for any refuse that could be recycled and put to other use. When their carts and prams were full to overflowing, they took them to dilapidated sorting sheds, where rags and metal were carefully separated, bagged and weighed, then collected by agents to sell to rag merchants and metal dealers.

Often, when I came to a cleared site and looked at the emptiness where rows and rows of terraced houses had once stood, I thought of all the care that must have gone into keeping those houses neat and clean – what a waste it all seemed by then – and I wondered about the comings and goings of the people and the dramas that must have been enacted over the years in the homes that were no longer there. But it was like standing on an empty stage; the actors had gone and there was nothing to show who they were or what the play had been about. Memories linger, but without some hint or trace of reality, they too die out and come to nothing. Perhaps these photographs will give substance to some of those memories.

Whole streets were disappearing and I hoped to capture some trace of the everyday life of the people who lived there. I was particularly interested in the more mundane, even trivial, aspects of life that were not being recorded by anyone else – rather than the more organised and official activities, such as Whit walks, that were documented each year by the local press.

I never posed people in my pictures but sometimes the children posed themselves when they spotted the camera. I liked to photograph their spontaneous reactions and often they would clamber all over me begging to have their photos taken, so it was difficult to get far enough away to focus the camera. After a while, most people relaxed and seemed to forget that I was there at all. I was also fascinated by the textures and abstract patterns created by age and time amongst the crazed paintwork and peeling facades of the old houses, but people caught my eye and I nearly always included them in the photographs.

Most of these photographs were taken on 35mm film with second-hand Leica, Contax and Minolta cameras. Occasionally, I used a tiny half-frame Pen camera but for some of the earlier photographs I used larger format Super Ikontas and Rolleiflex cameras with 120 size film. I often used standard lenses with the 35mm cameras, but later was converted to using zooms which enabled me to change the focal length rapidly when I needed to, without missing pictures. I used Kodachrome 64 for all the colour photos.

My interest in photography goes back to childhood so it seemed logical after leaving school to enrol as a student at Manchester College of Technology and take a full-time course in photography. After completing the course, I worked as a photographer in industry, as a teacher and as a freelance. Freelancing appeals most of all because of the illusion of self-ownership it gives me.

There are many photographers whose work I greatly admire and I remember that I wanted to capture "slice of life" pictures à la Cartier-Bresson. But, if I ever tried to imitate the style of another photographer, the results were always disappointing and false. So this was the scene as I saw it. These are *my* pictures but they are the observations of one person and they tell only a fraction of the story.

SHIRLEY BAKER

STREET
PHOTOGRAPHS

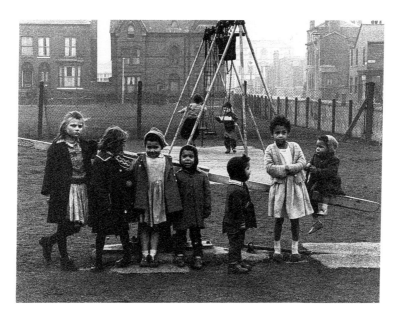

MANCHESTER 1964

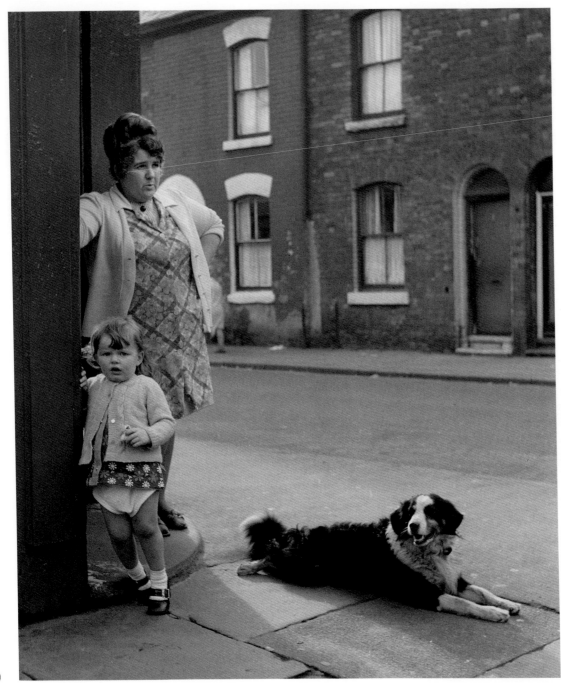

20

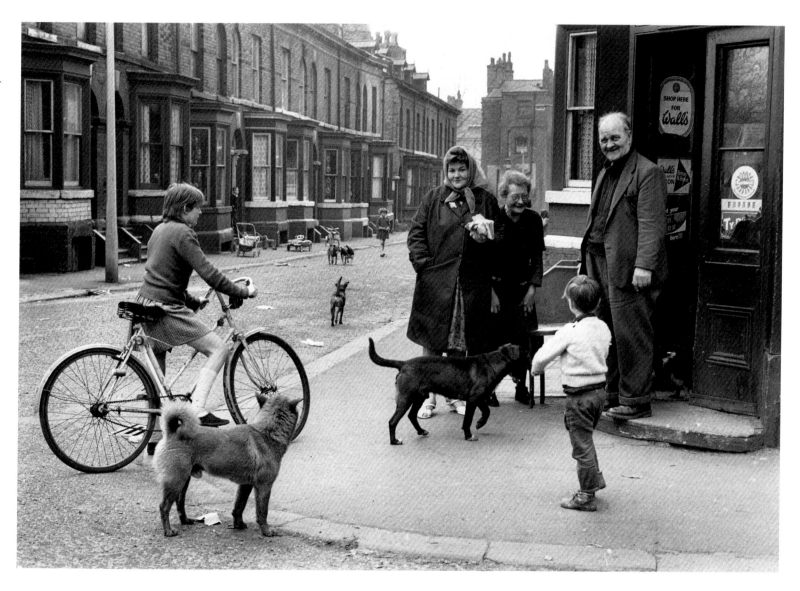

MANCHESTER 1968

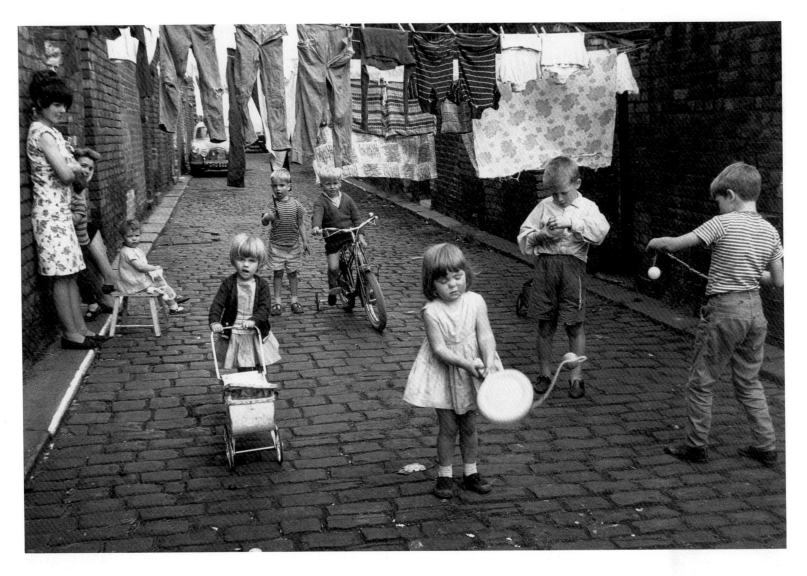

MANCHESTER 1966

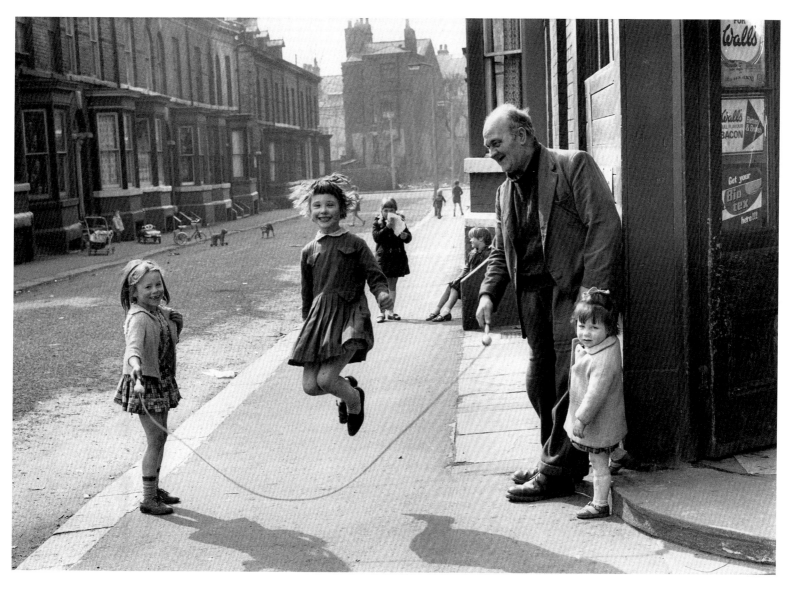

MANCHESTER 1968

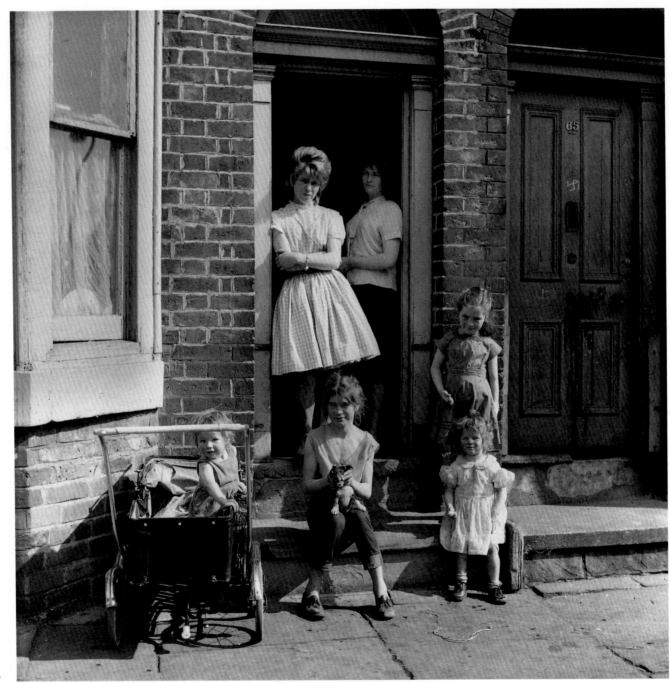

MANCHESTER 1963

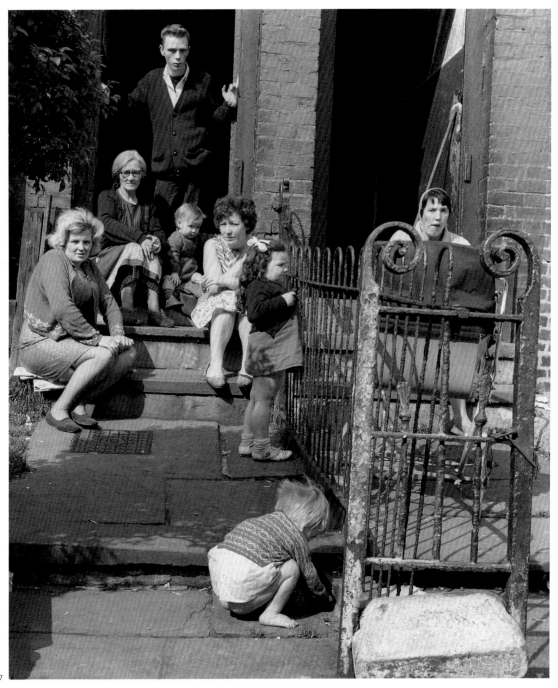

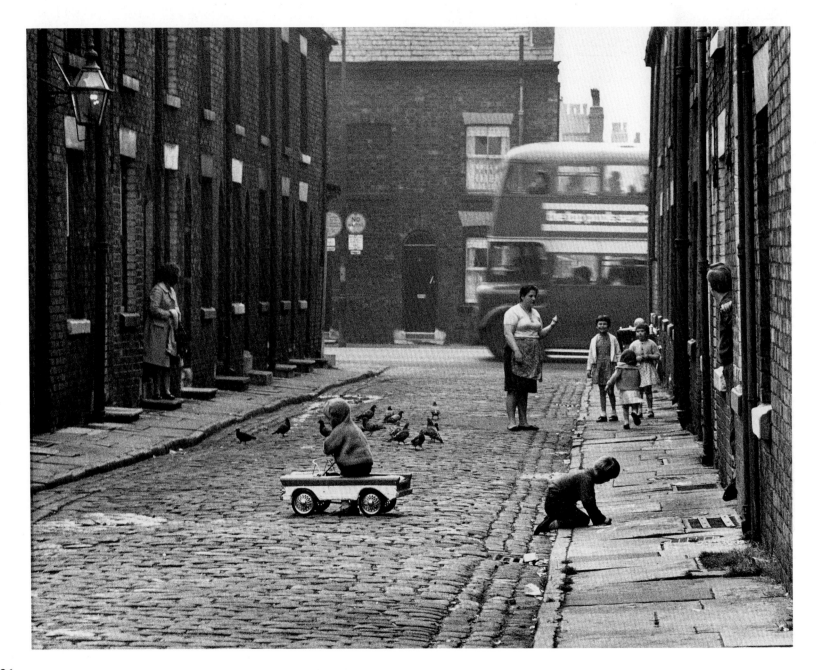

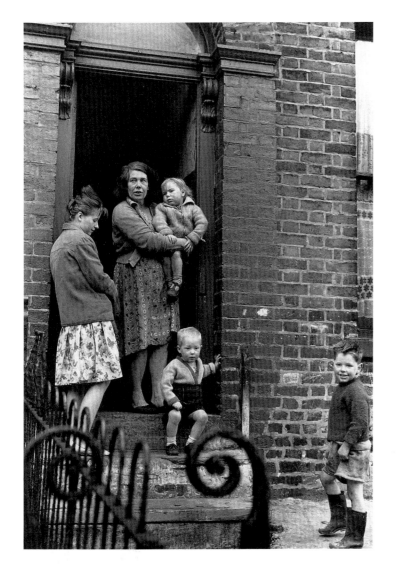

MANCHESTER 1964

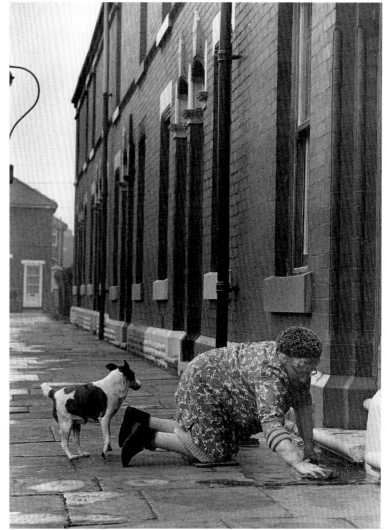

MANCHESTER 1968

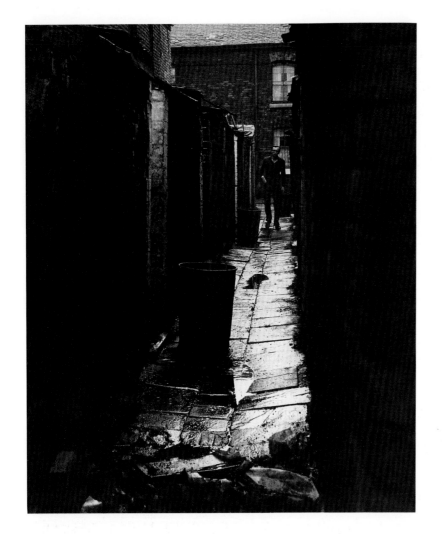

SALFORD 1970

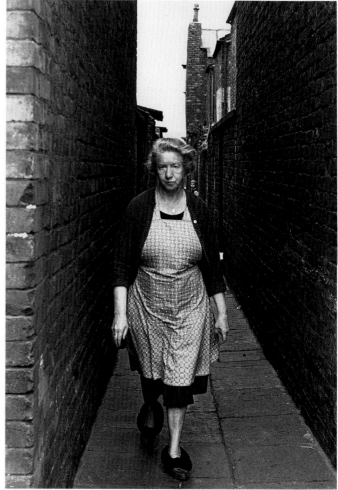

SALFORD 1964

28

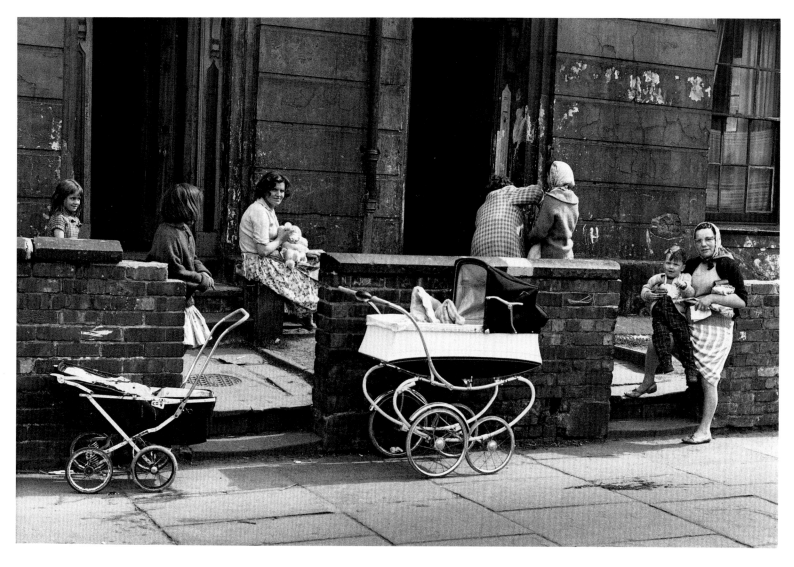

MANCHESTER 1964

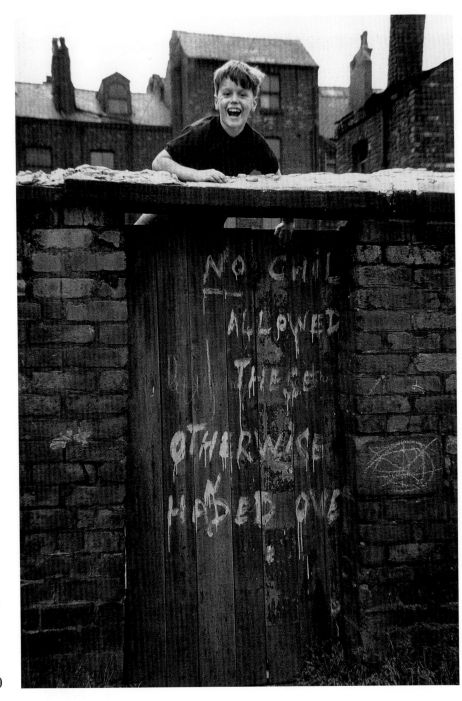

30

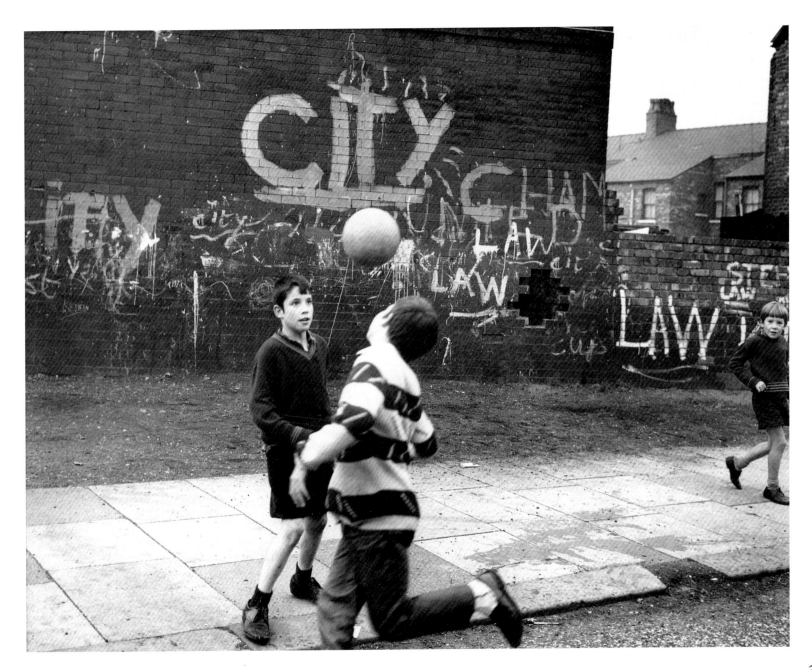

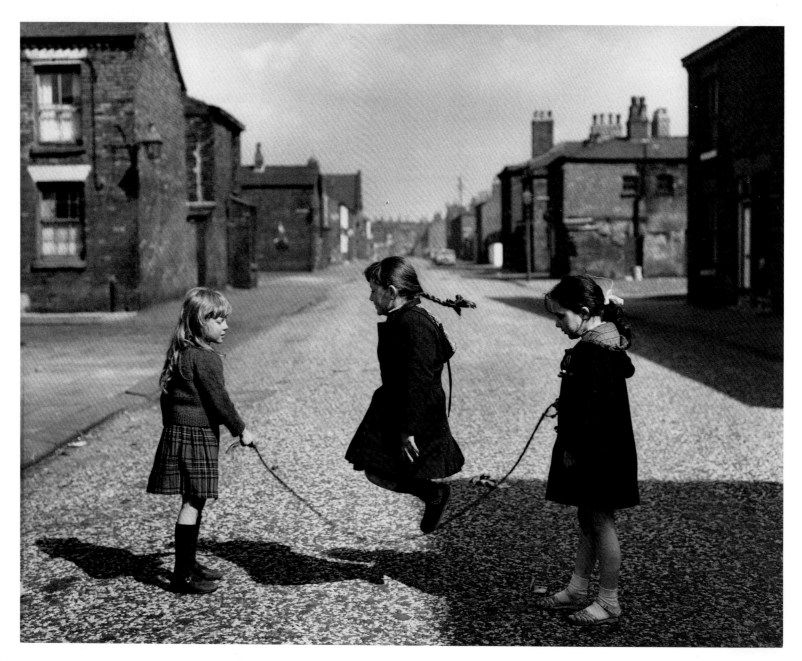

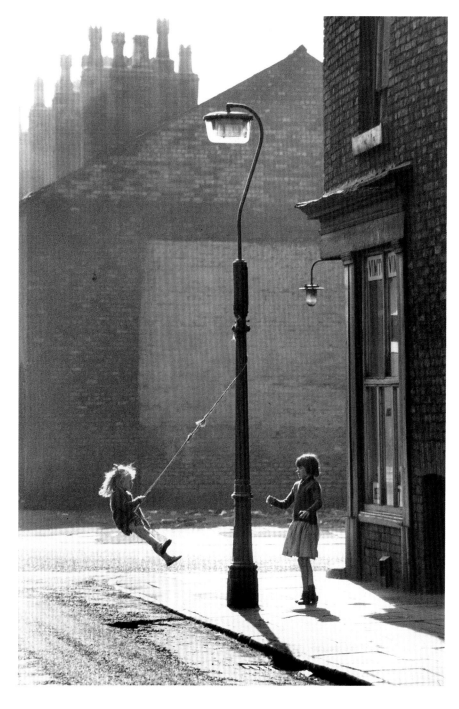

HULME 1965

33

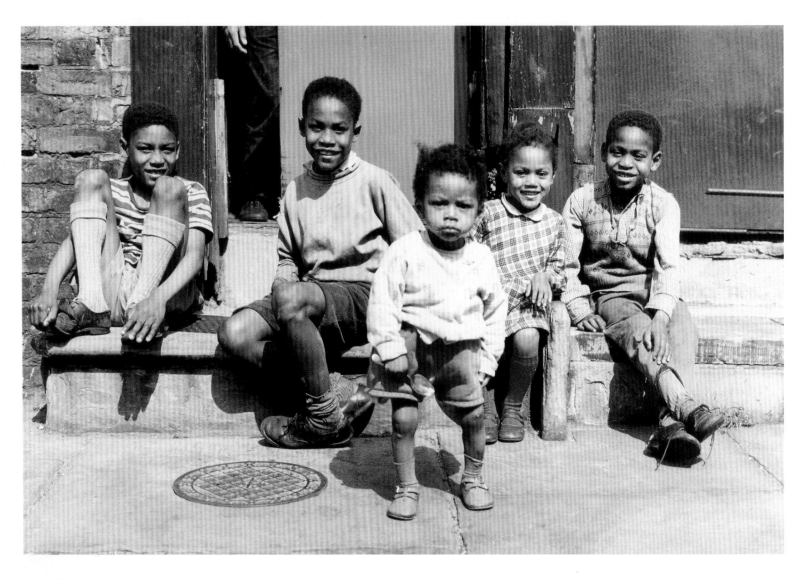

HULME 1965

34

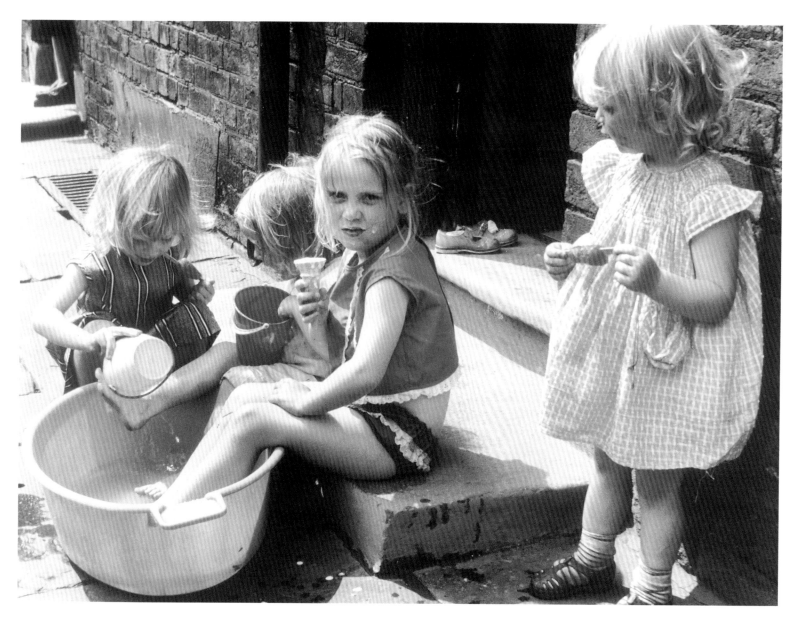

HULME 1965

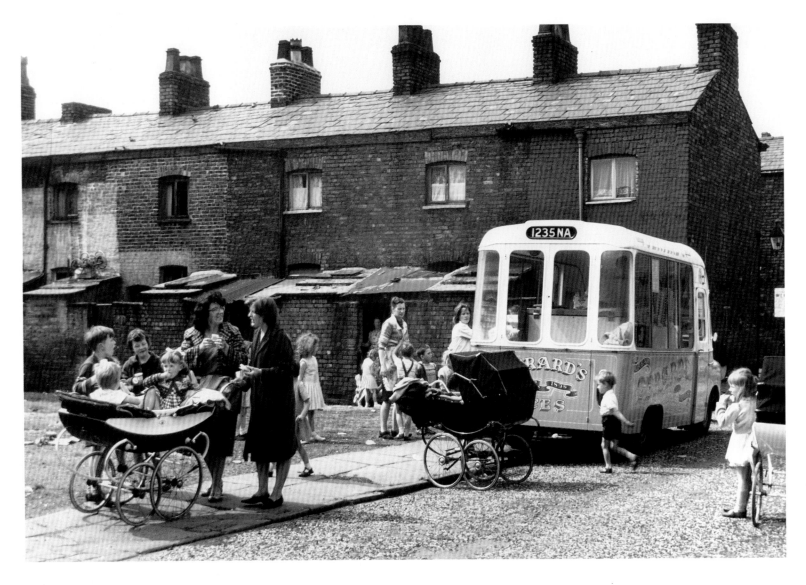

HULME 1965

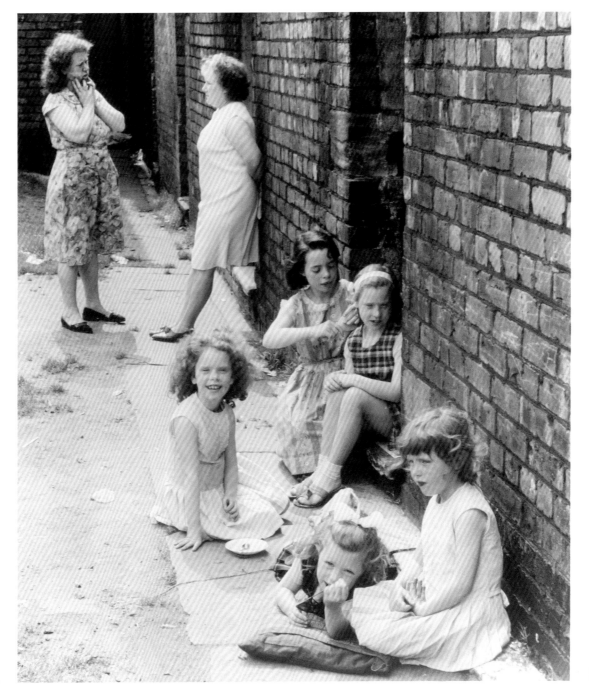

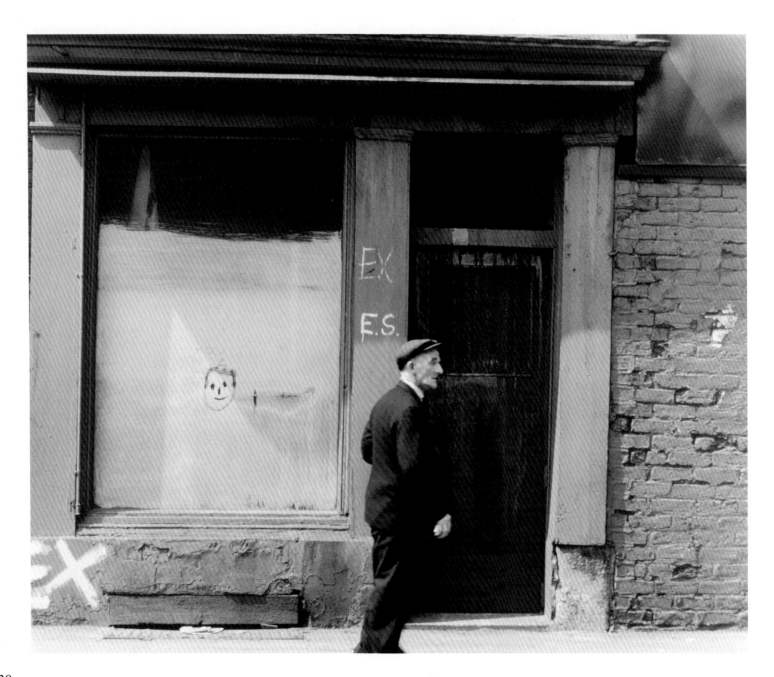

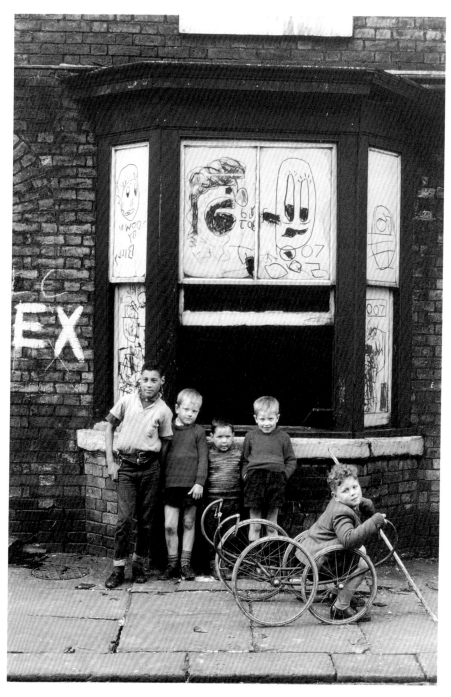

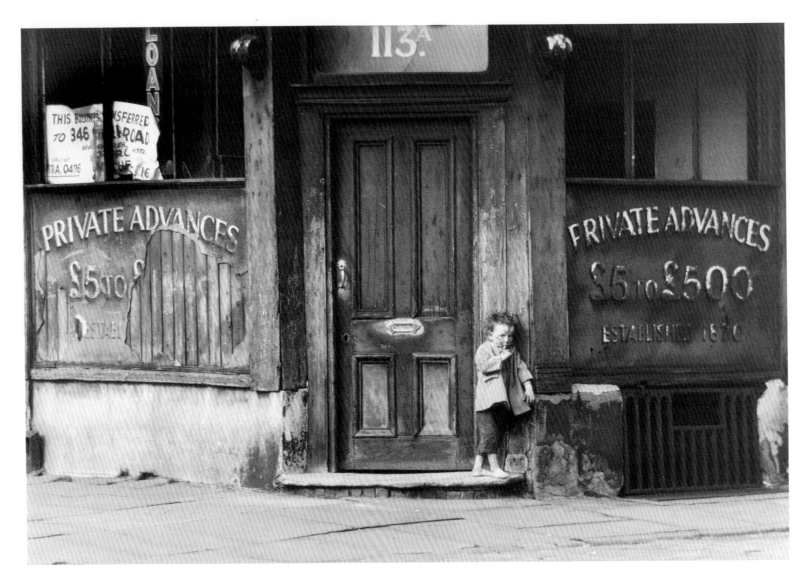

HULME 1965

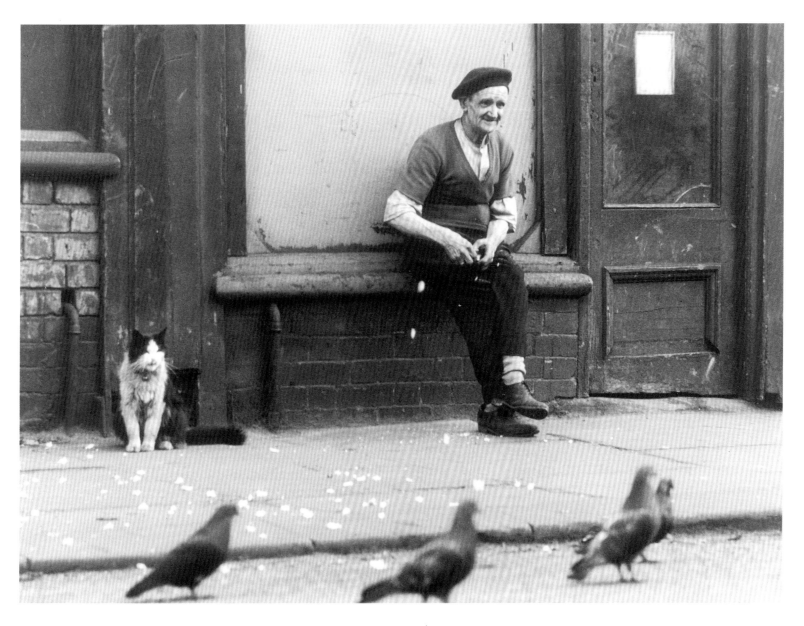

HULME 1965

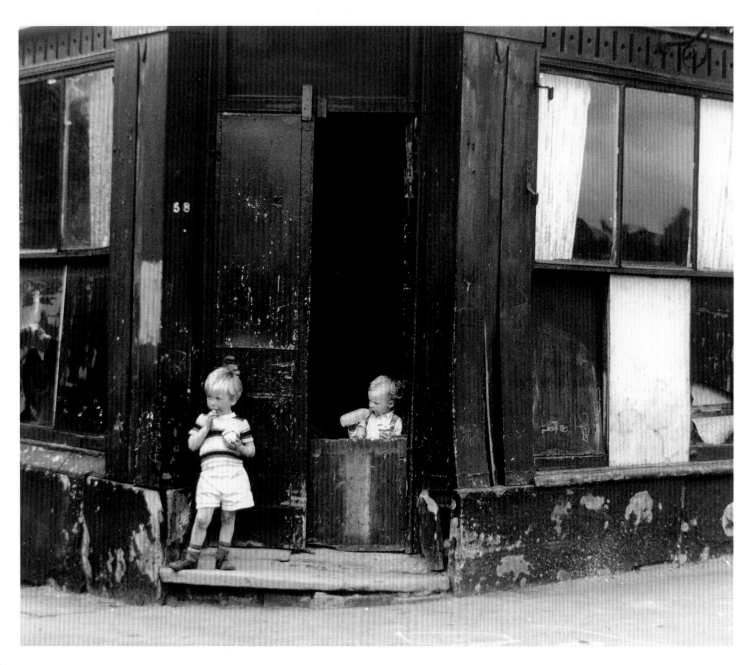

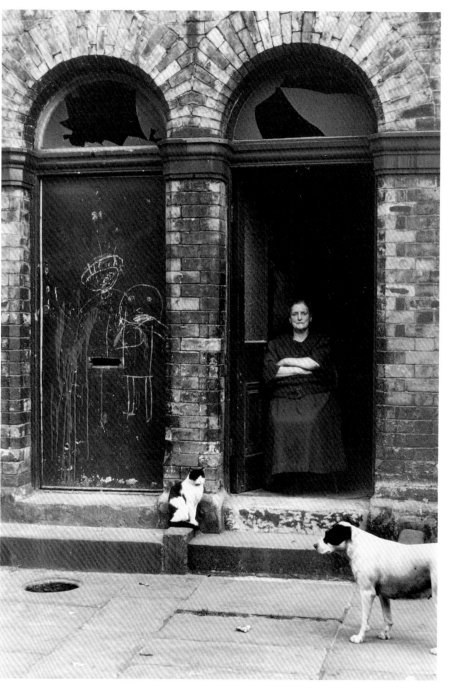

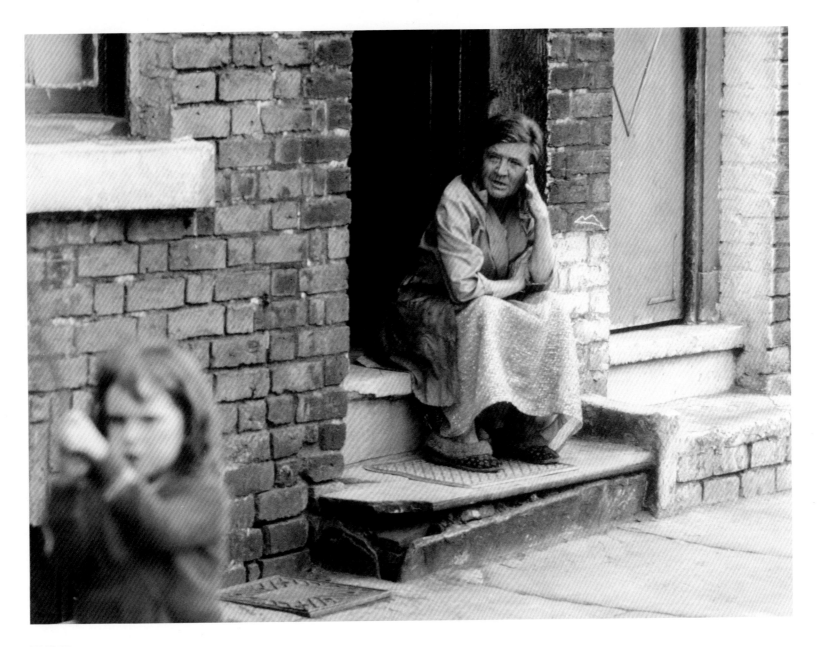

HULME 1965

44

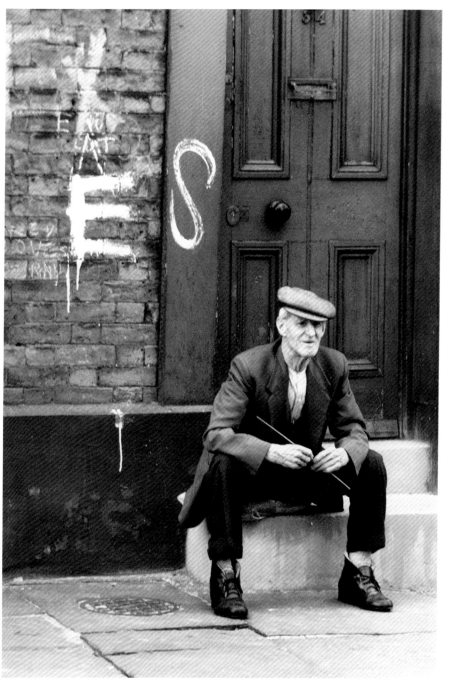

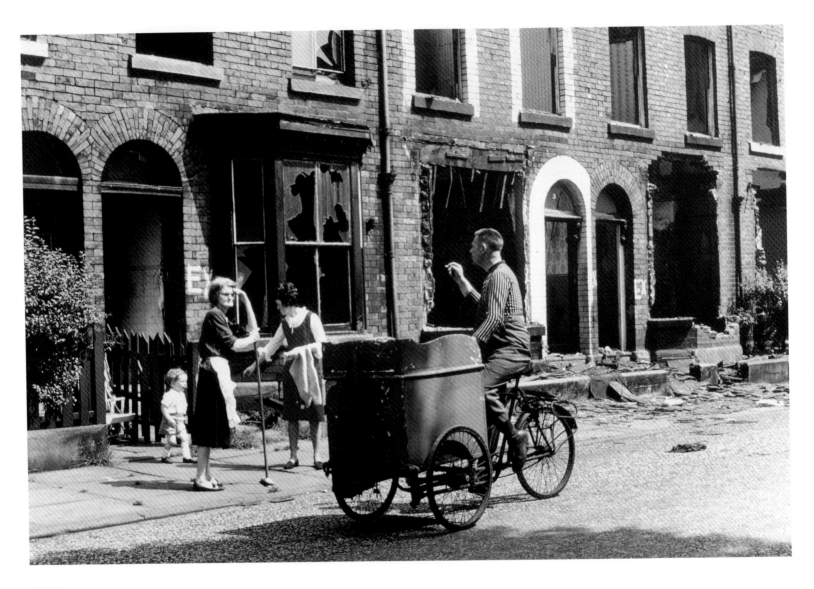

HULME 1965

46

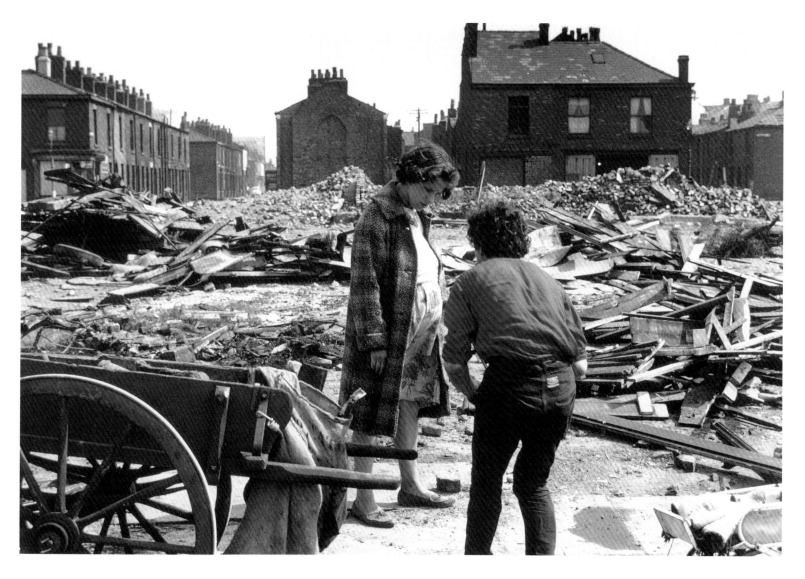

HULME 1965

47

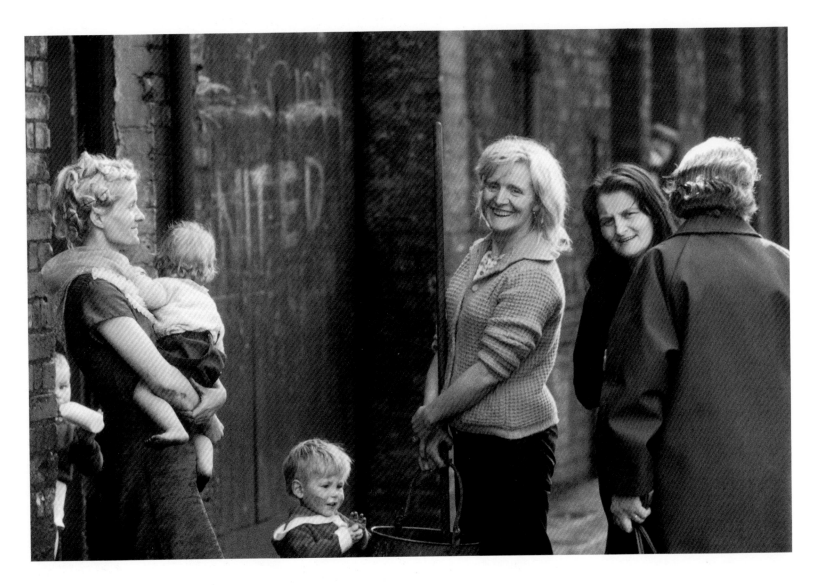

HULME 1965

48

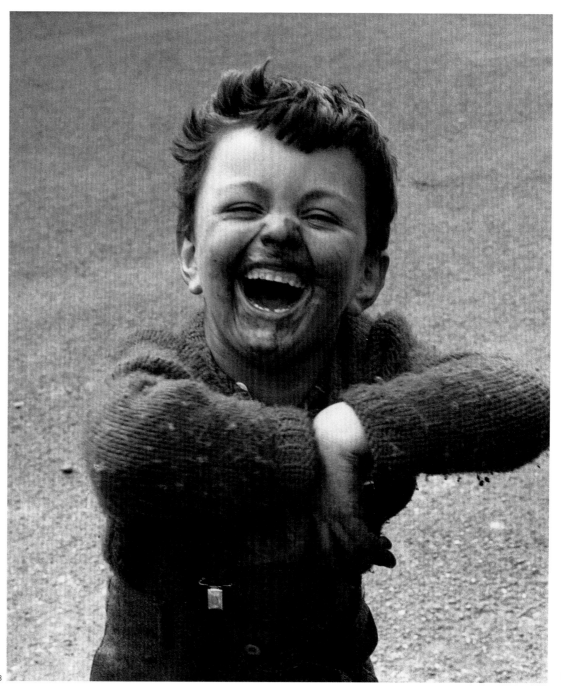

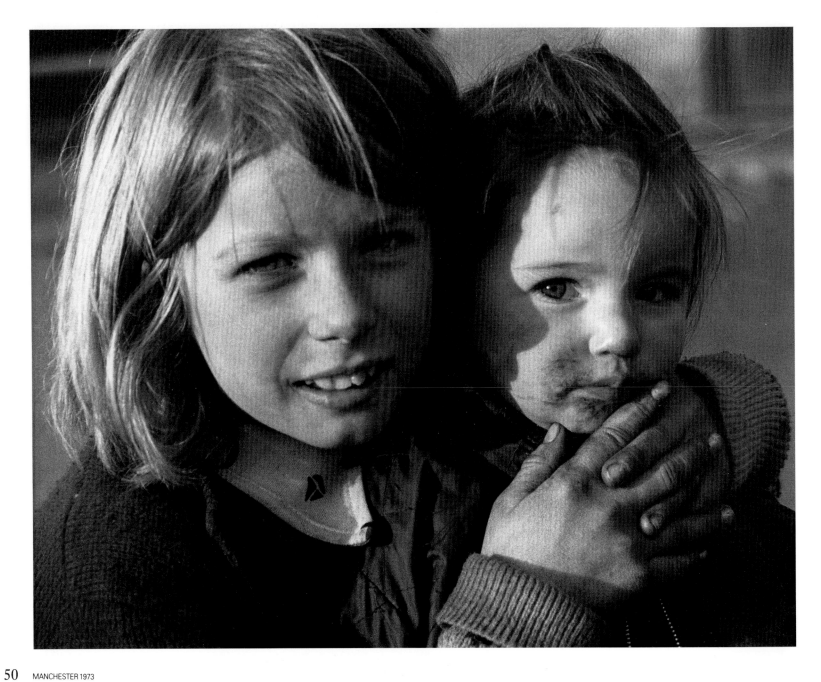

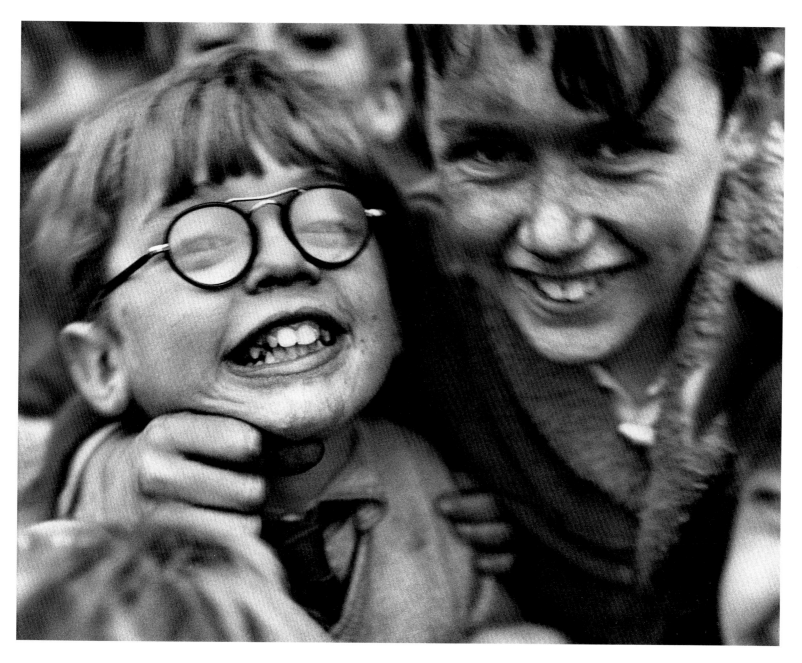

SALFORD 1965

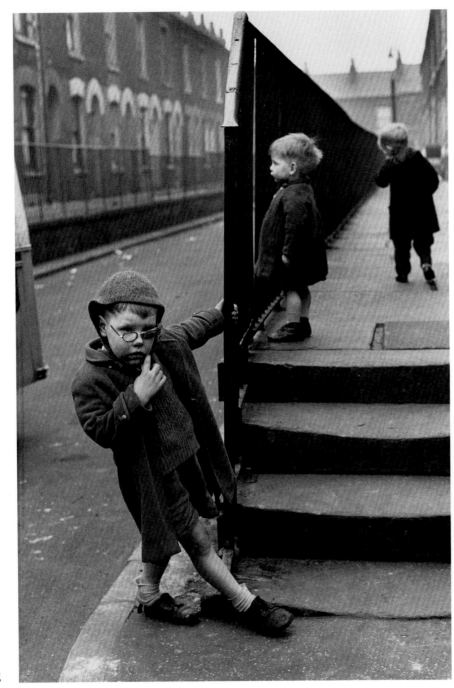

SALFORD 1964

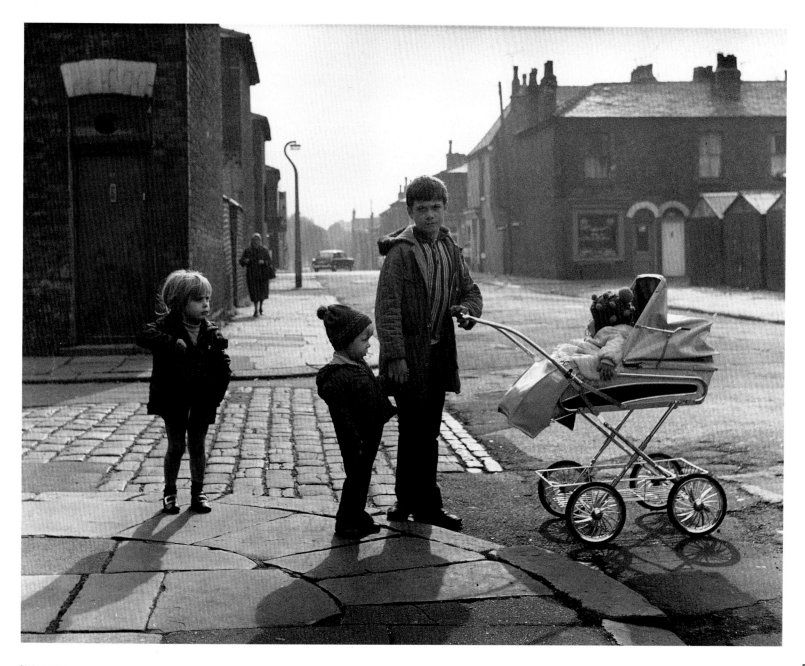

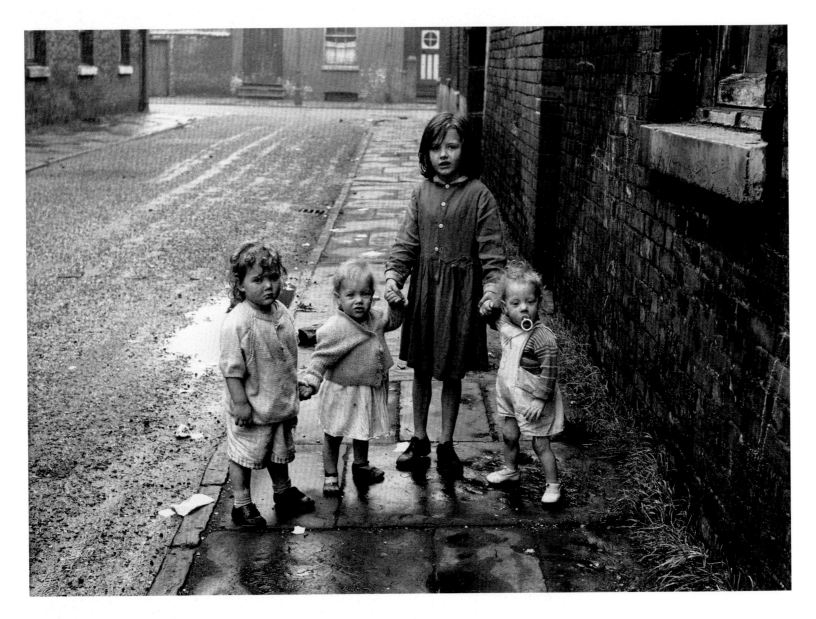

MANCHESTER 1963

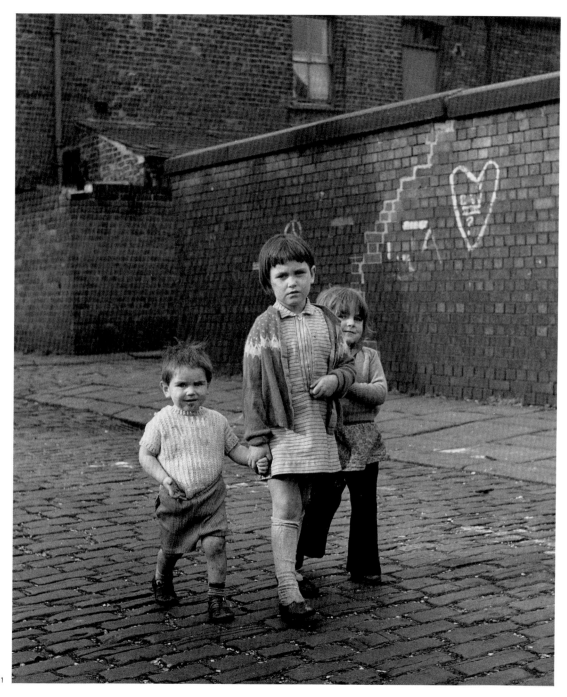

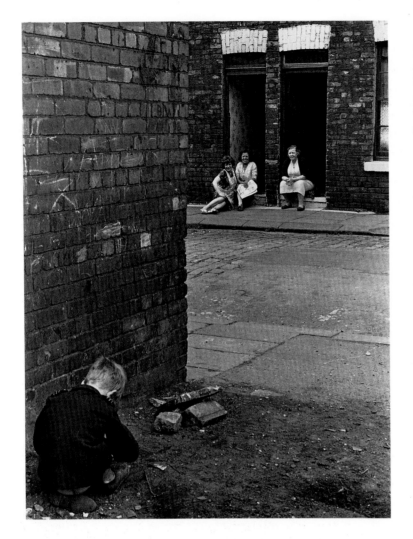

SALFORD 1964

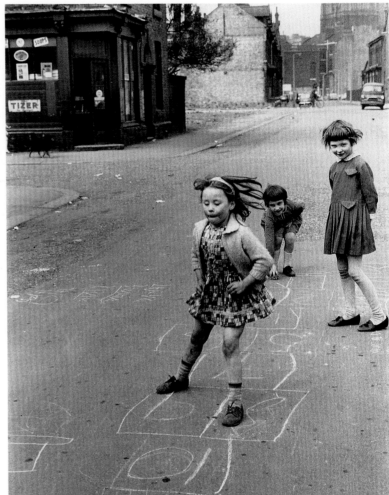

MANCHESTER 1968

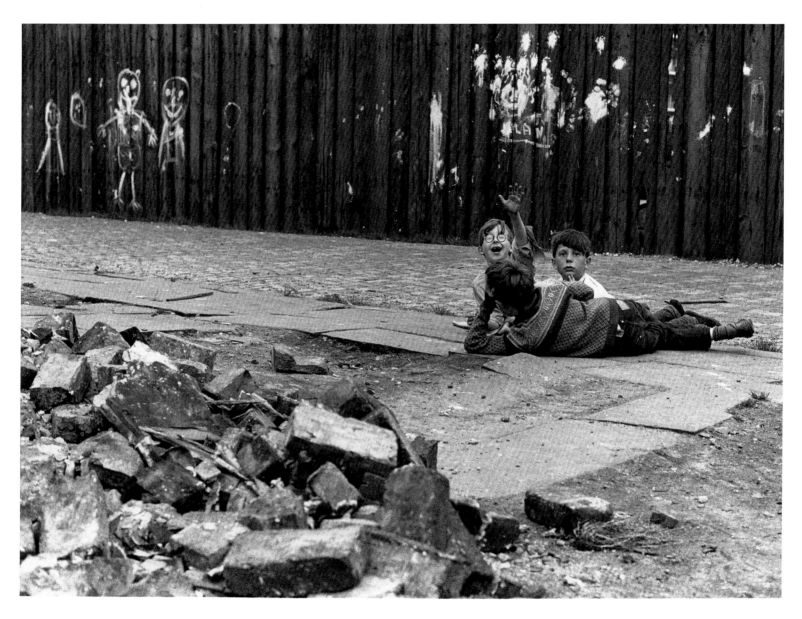

SALFORD 1964

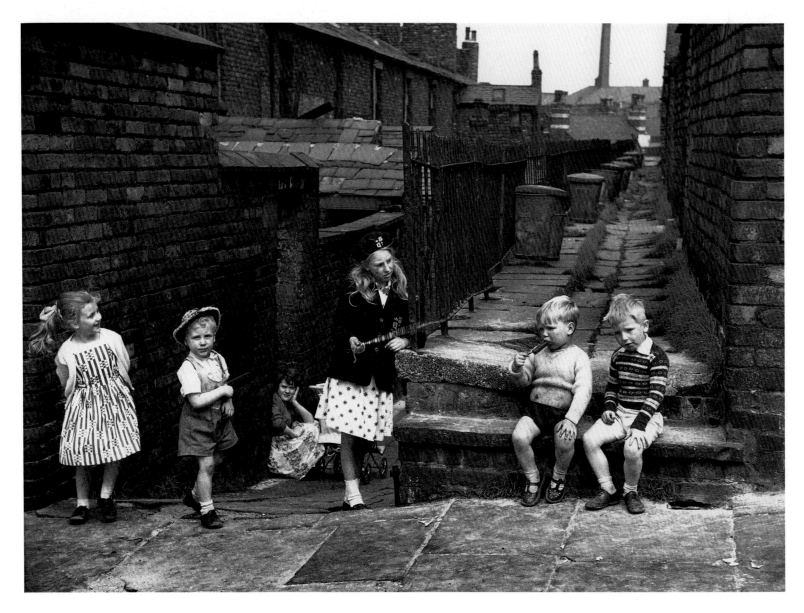

SALFORD 1962

58

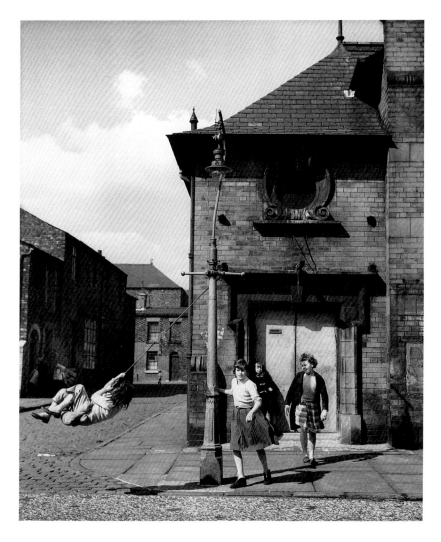

MANCHESTER 1962

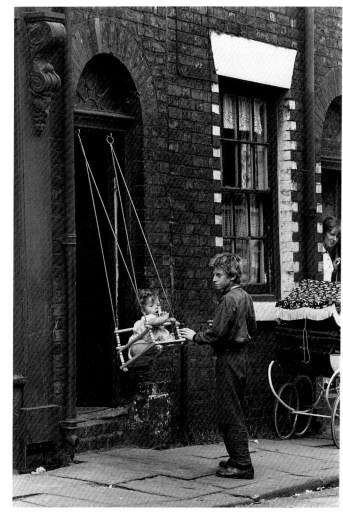

SALFORD 1964

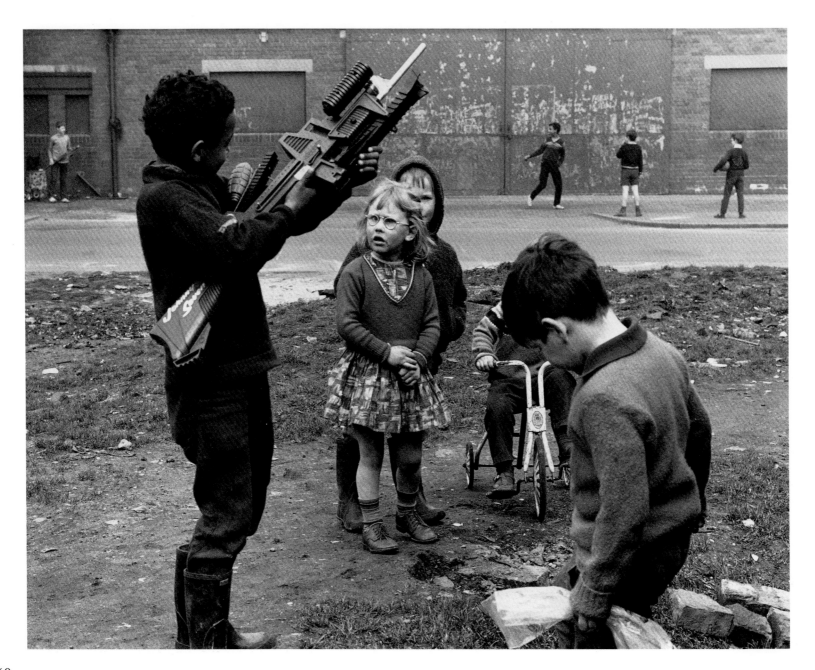

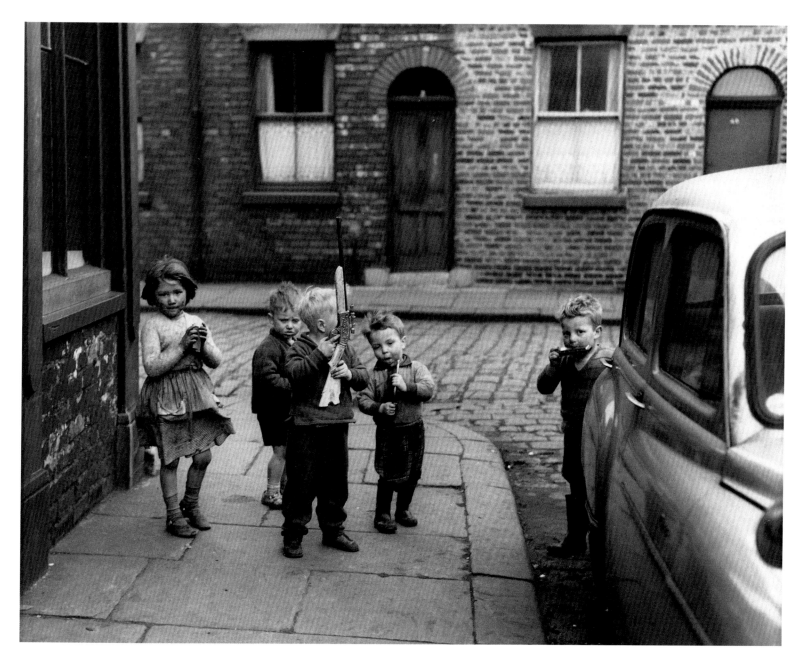

SALFORD 1961

61

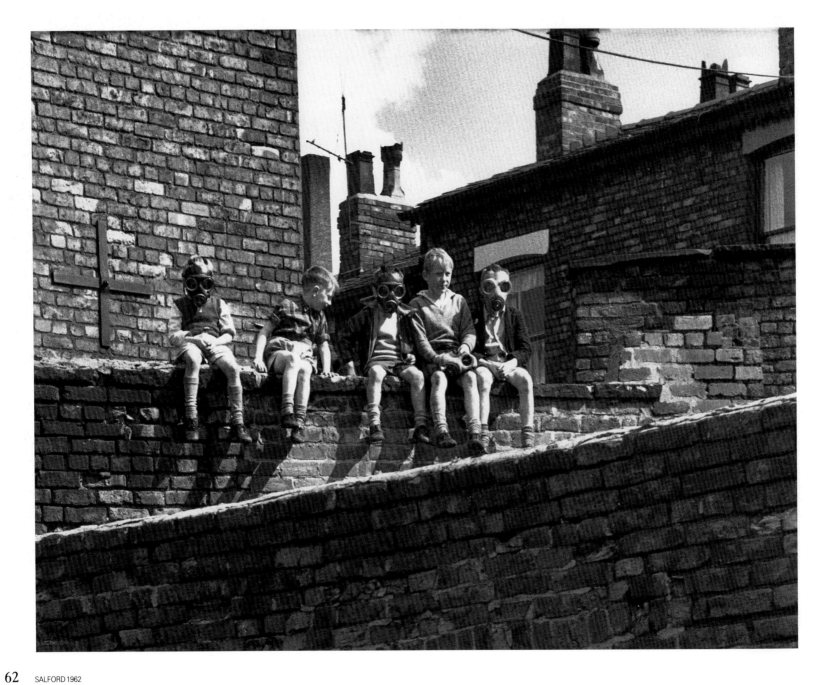

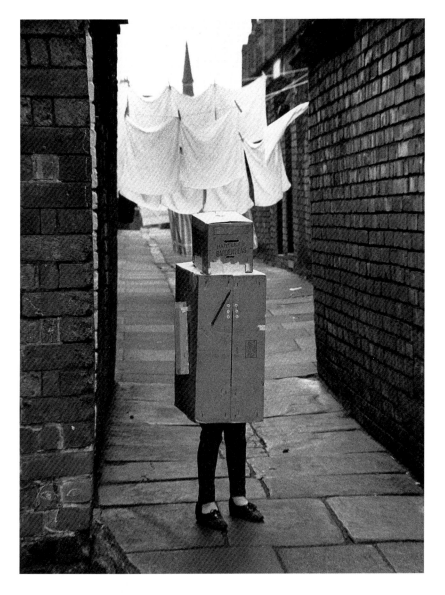

MANCHESTER 1966

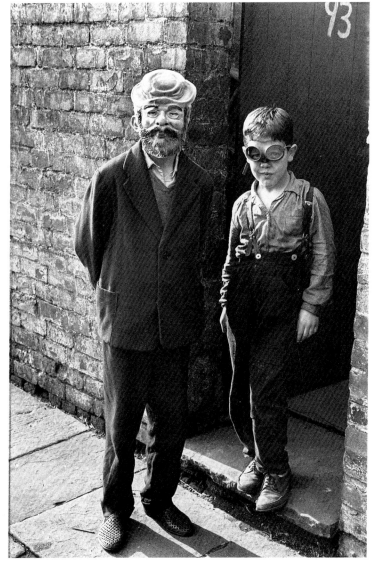

MANCHESTER 1965

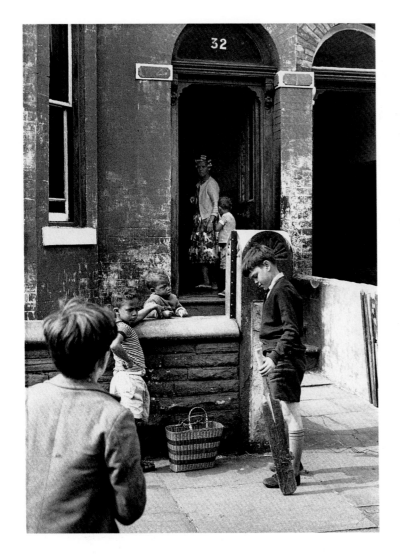

MANCHESTER 1964

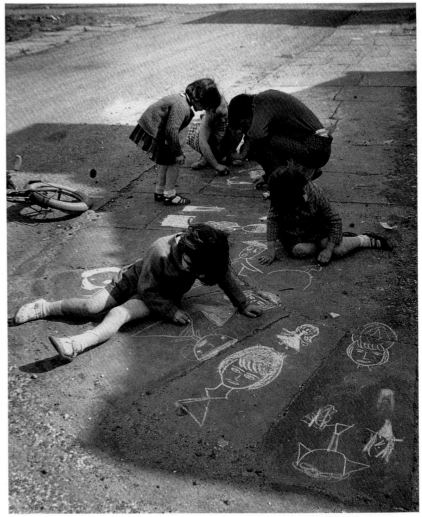

MANCHESTER 1966

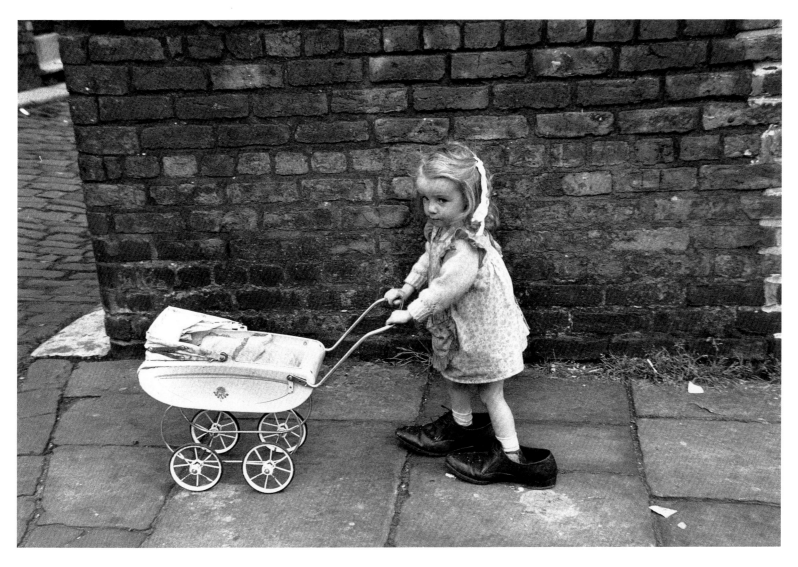

MANCHESTER 1966

65

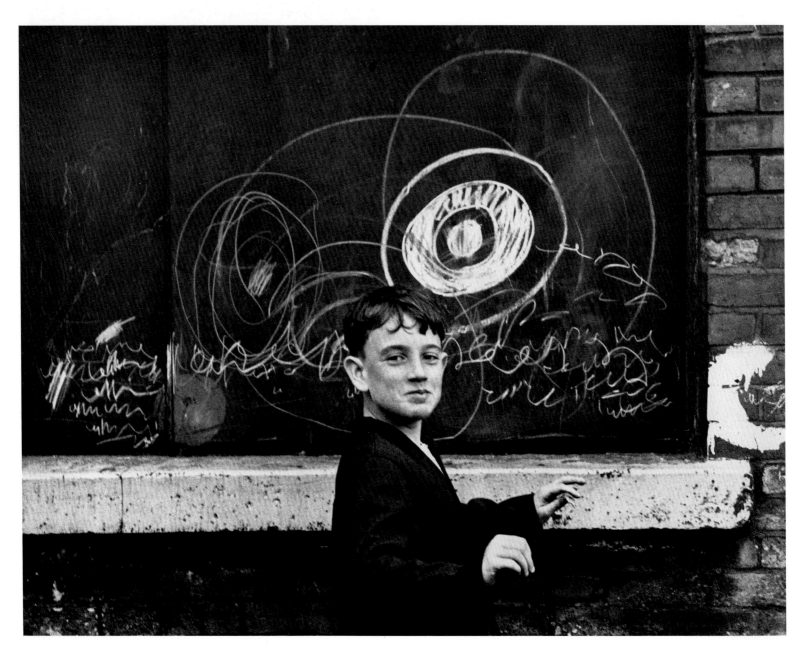

MANCHESTER 1967

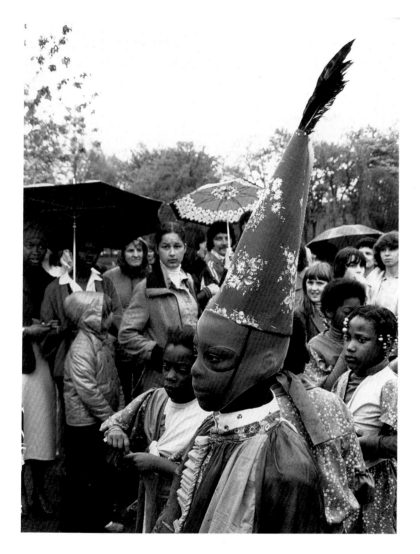

MANCHESTER 1979

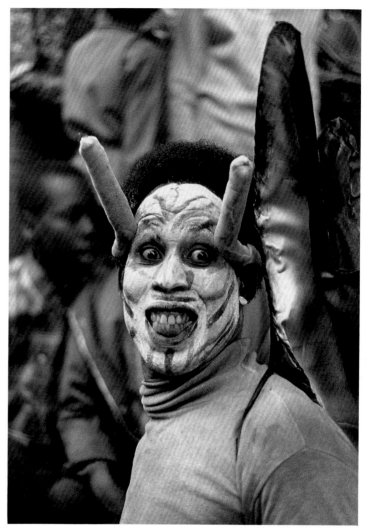

MANCHESTER 1973

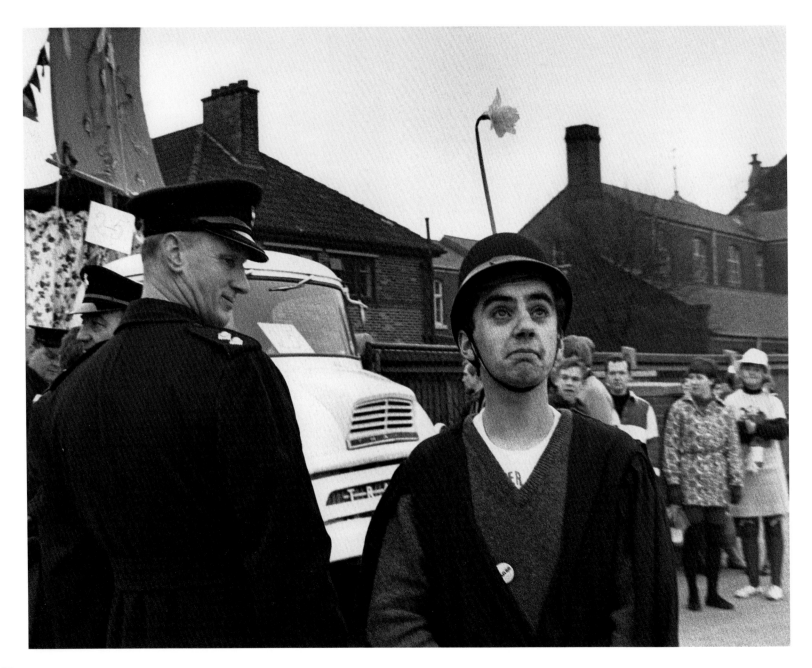

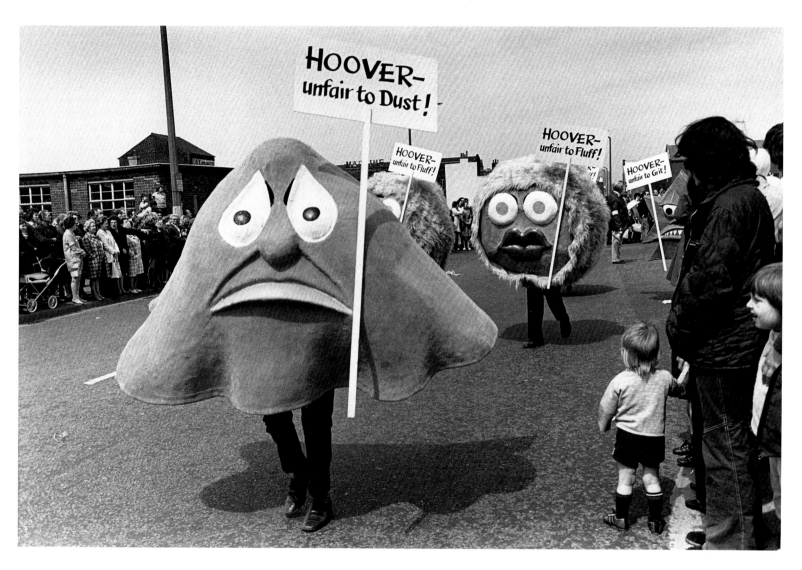

MANCHESTER 1973

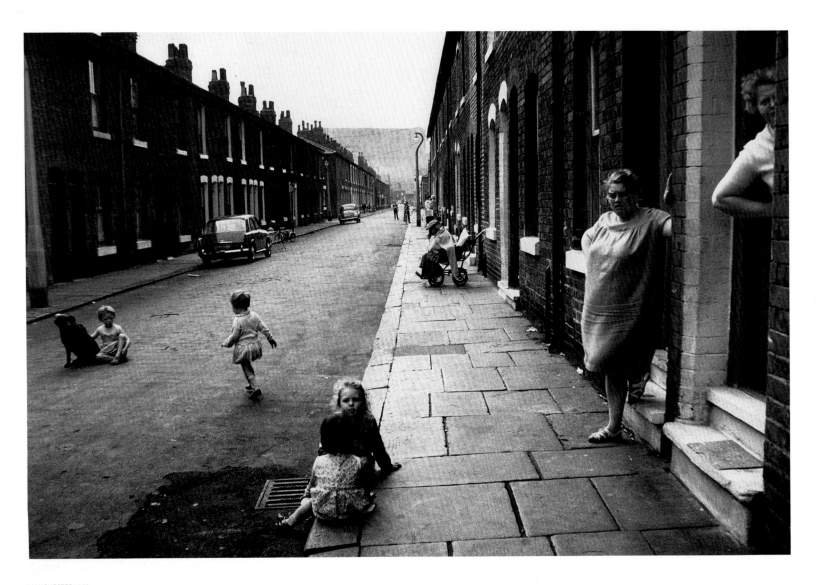

MANCHESTER 1966

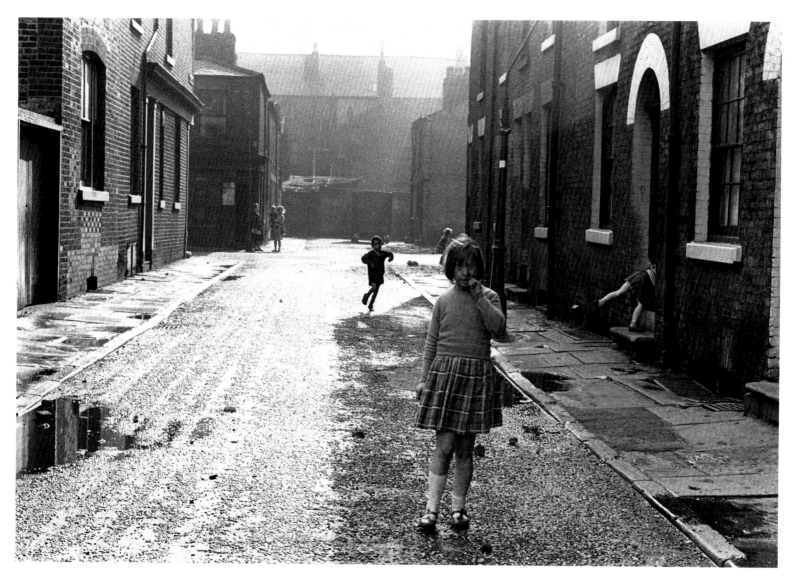

MANCHESTER 1966

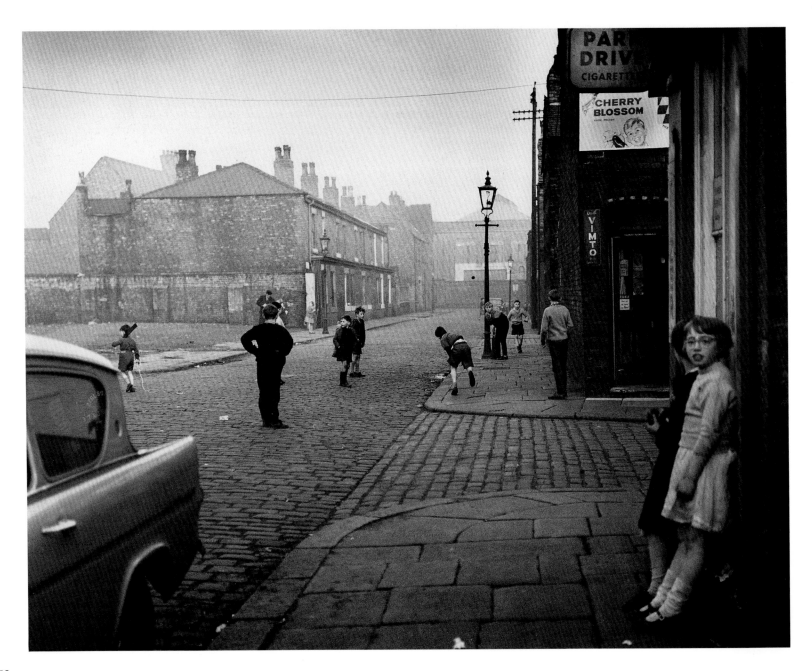

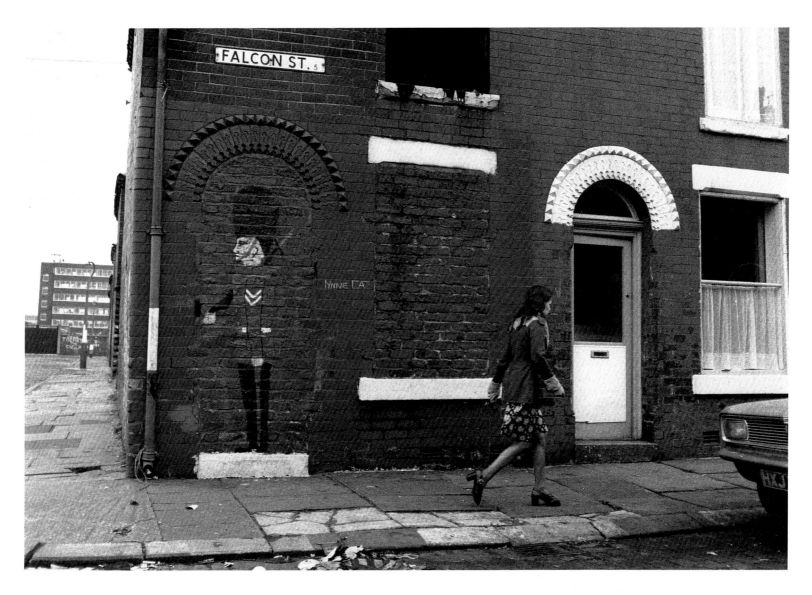

SALFORD 1978

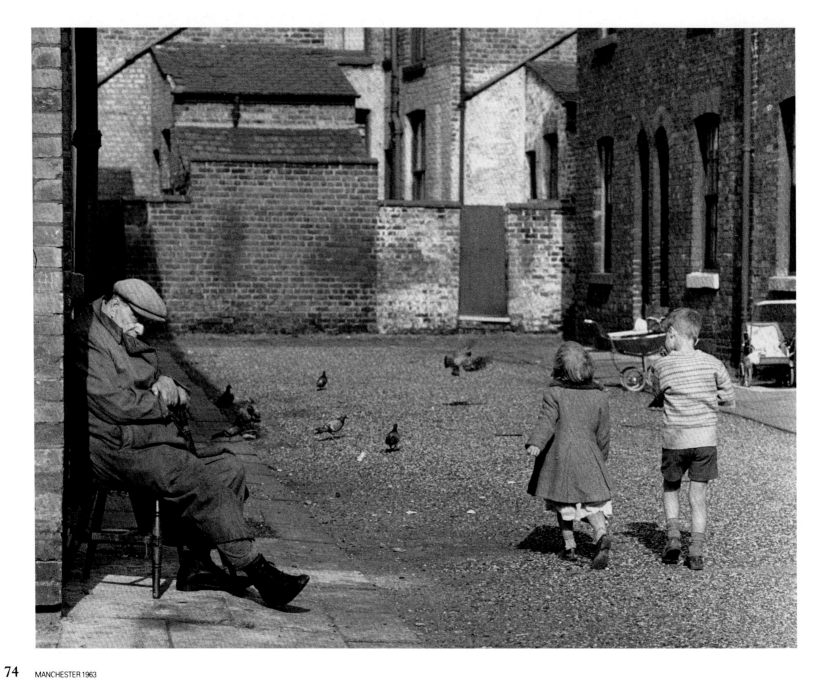

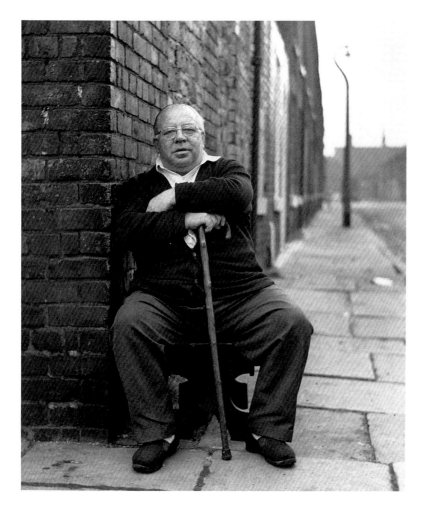

SALFORD 1971

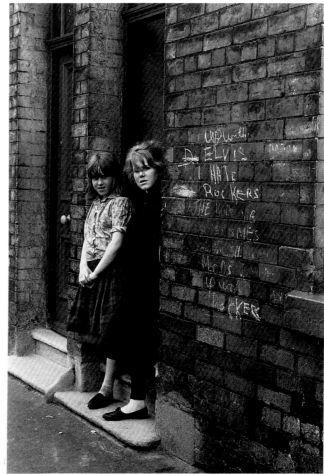

SALFORD 1964

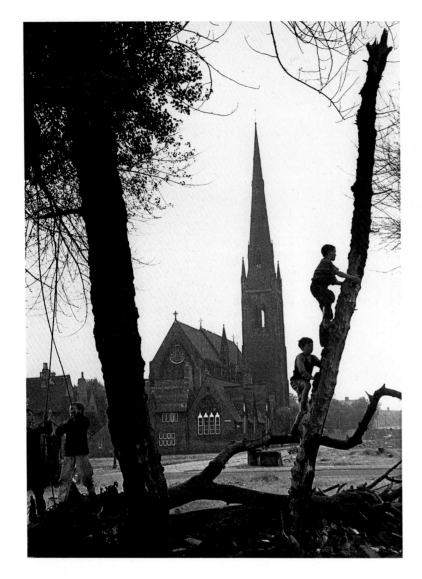

MANCHESTER 1966

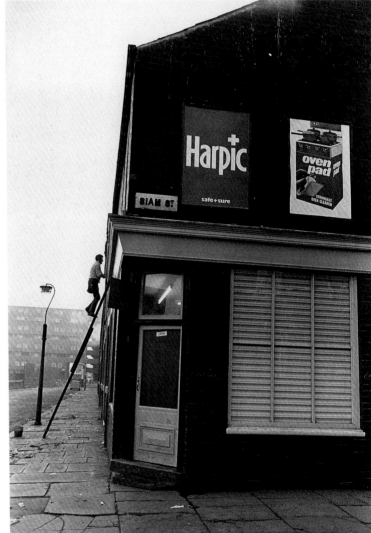

MANCHESTER 1973

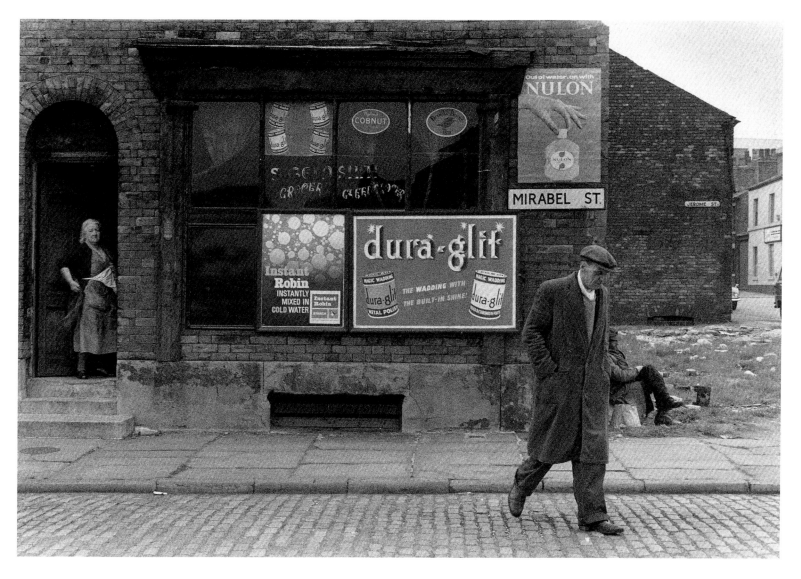

MANCHESTER 1965

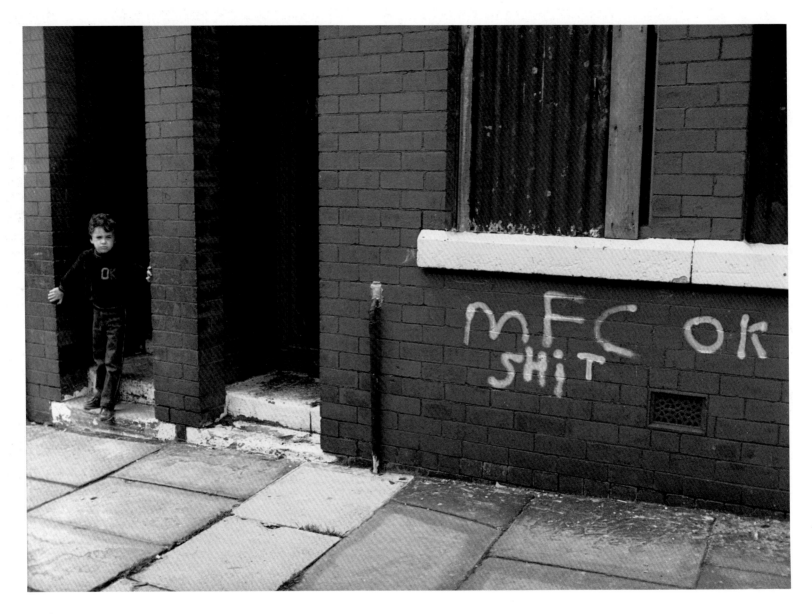

SALFORD 1981

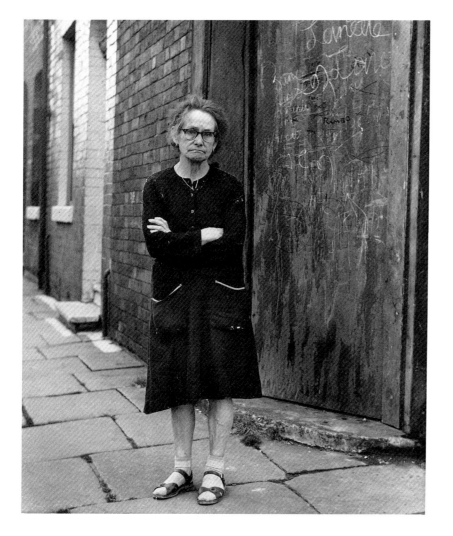

SALFORD 1971

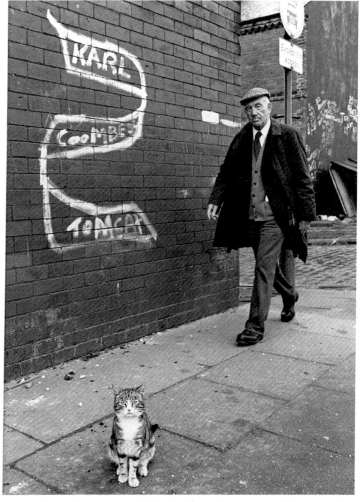

SALFORD 1981

79

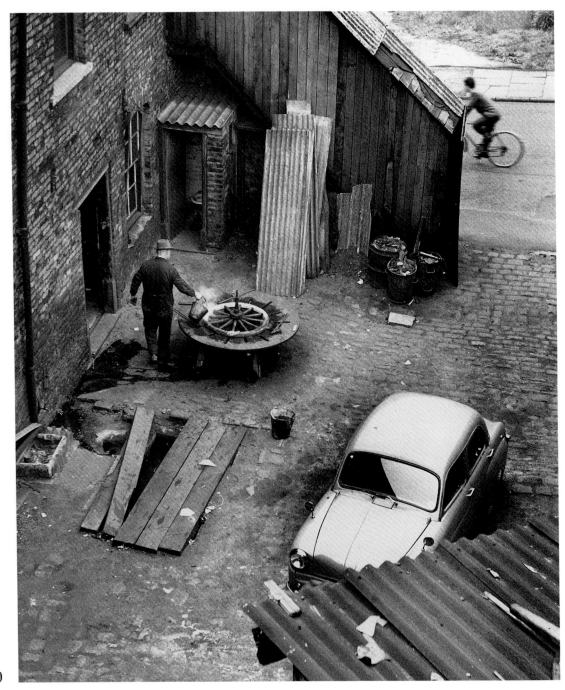

80

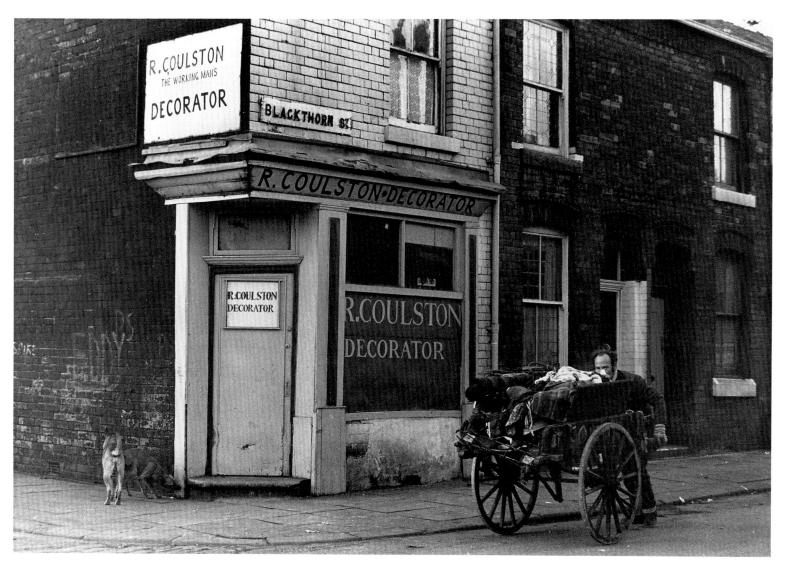

MANCHESTER 1973

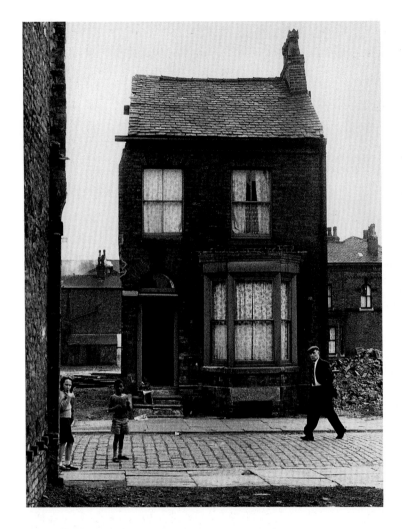

MANCHESTER 1964

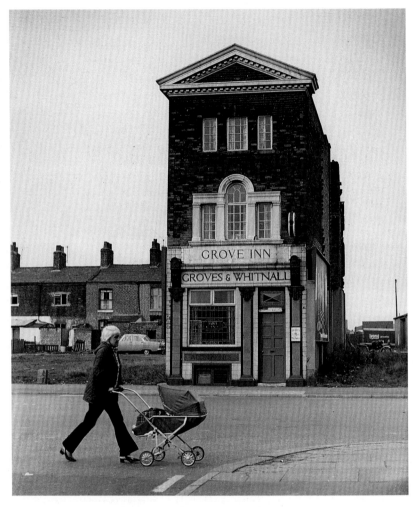

SALFORD 1971

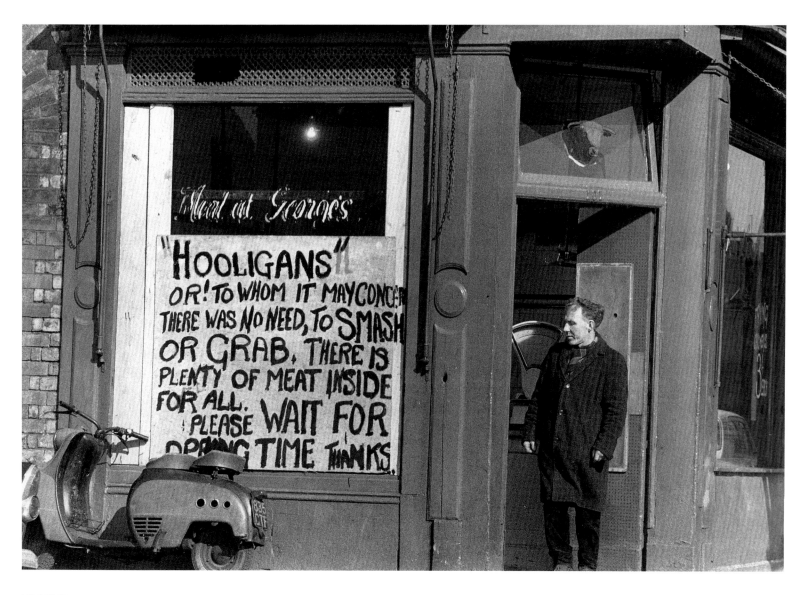

MANCHESTER 1966

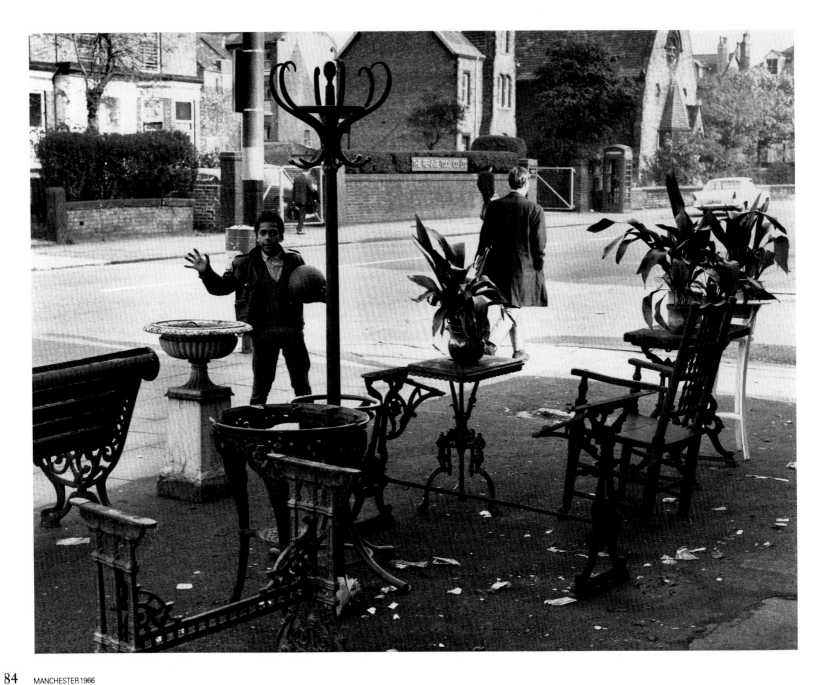

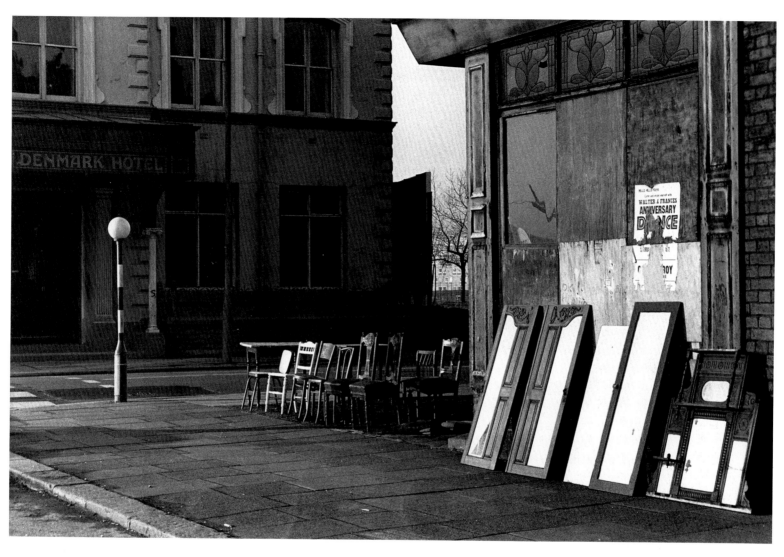

MANCHESTER 1973

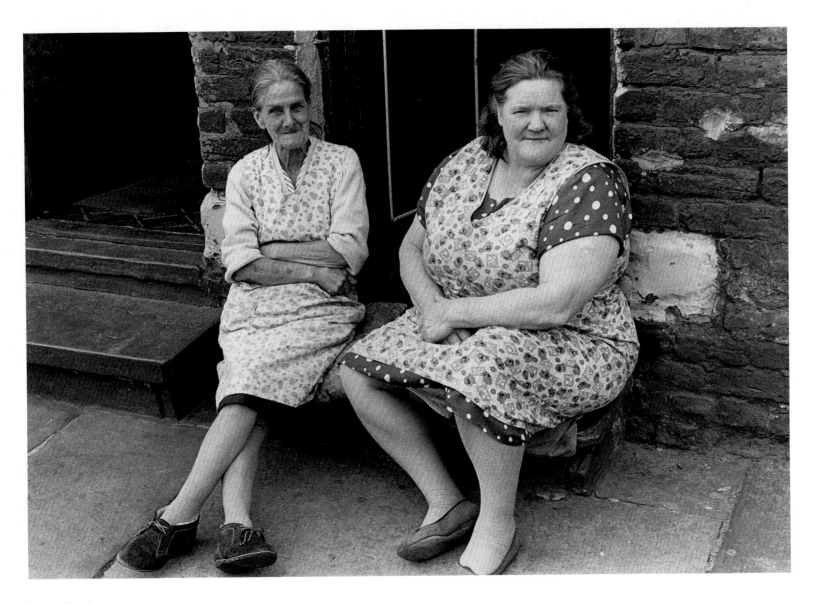

MANCHESTER 1967

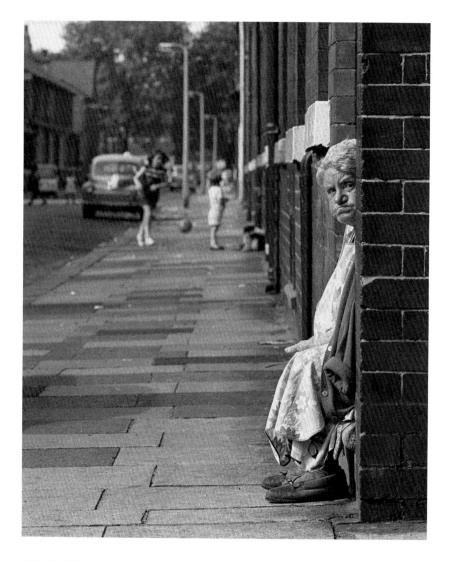

MANCHESTER 1968

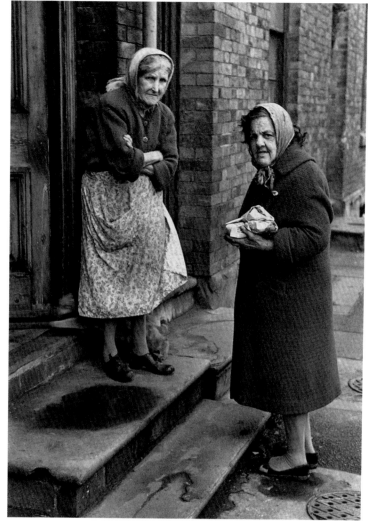

MANCHESTER 1966

87

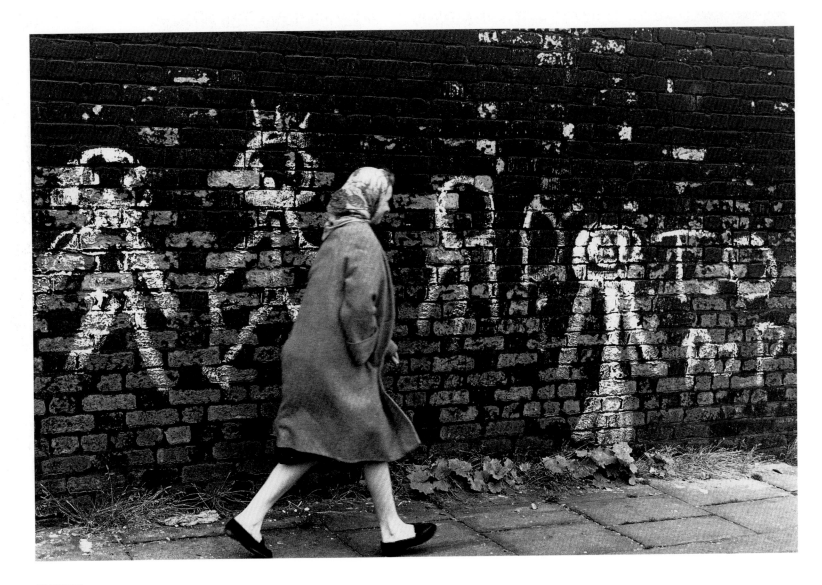

SALFORD 1964

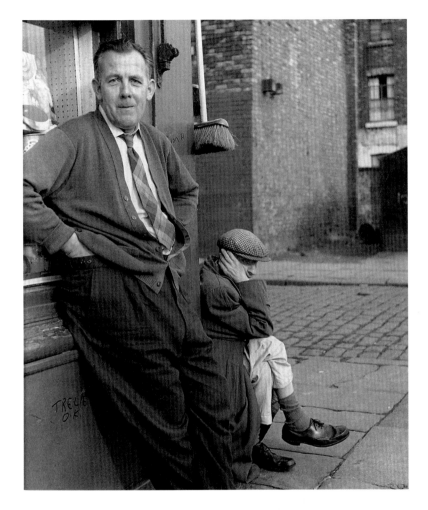

SALFORD 1971

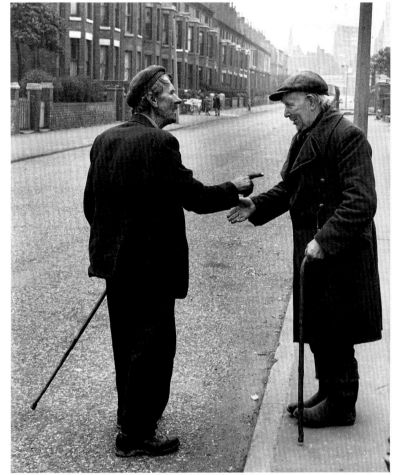

MANCHESTER 1968

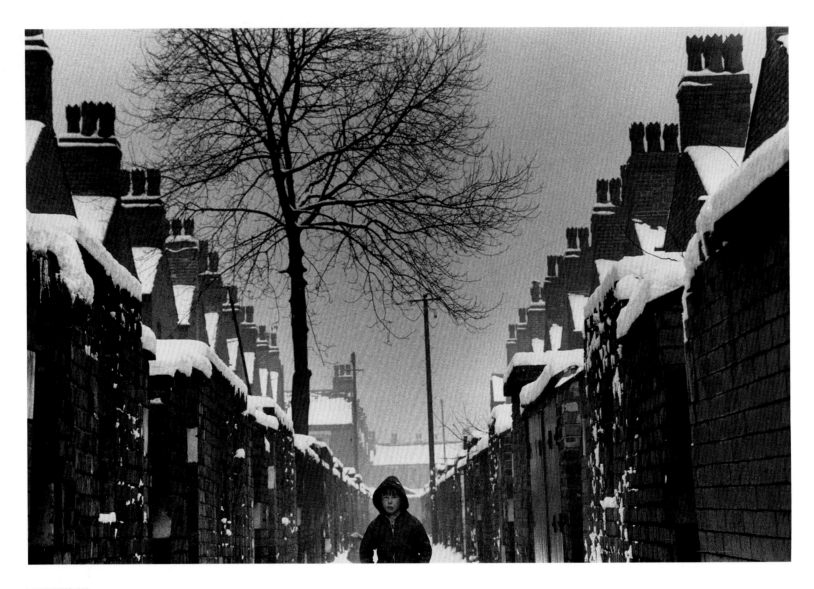

MANCHESTER 1968

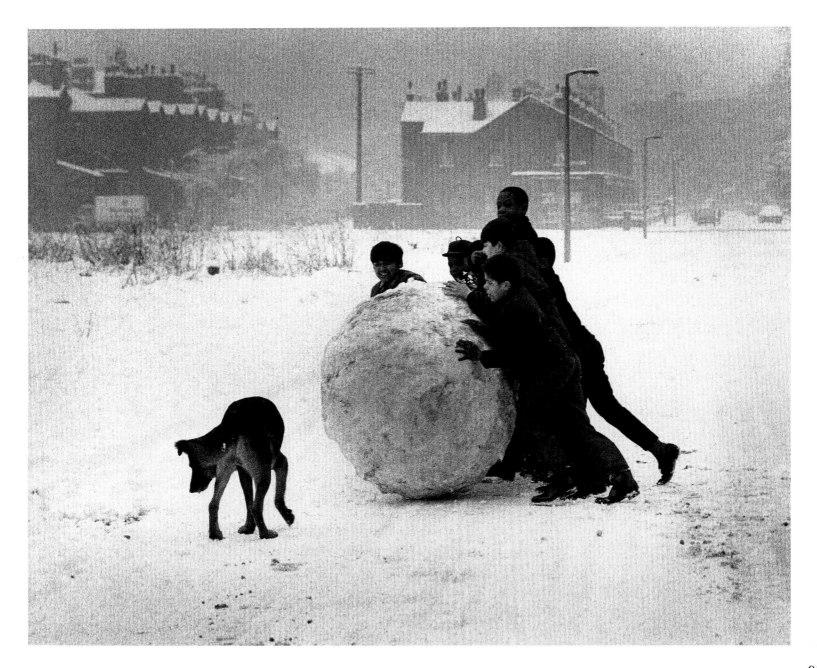

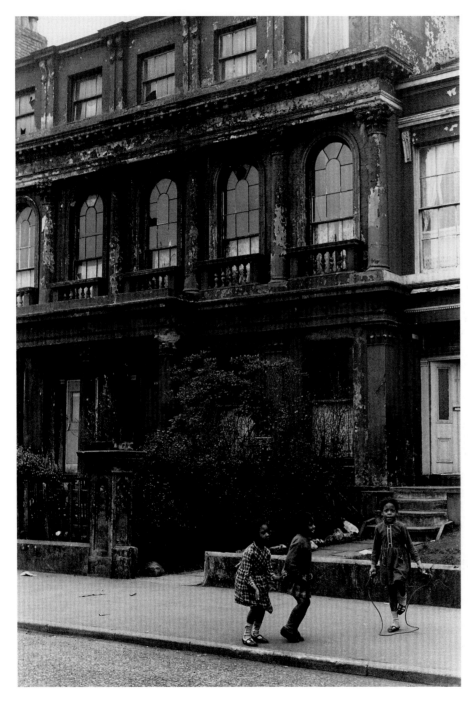

MANCHESTER 1968

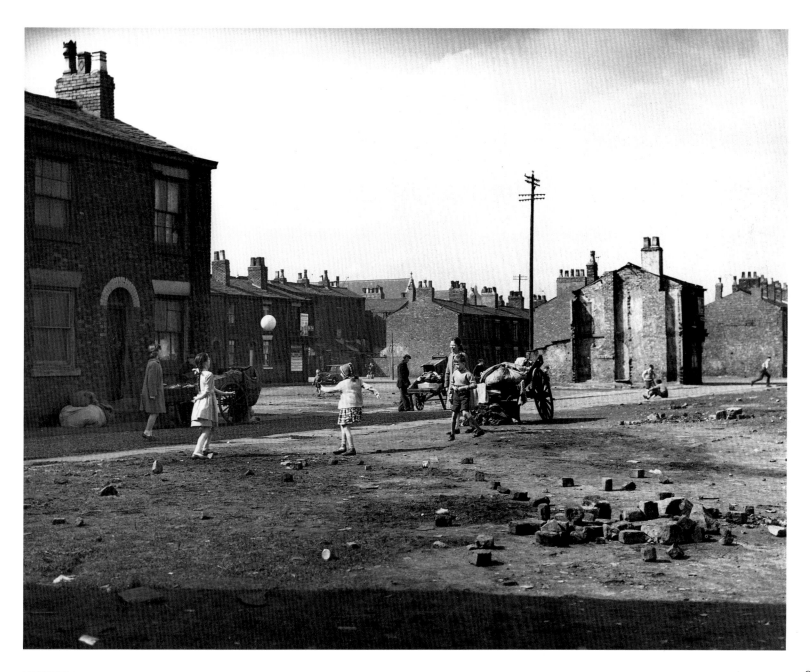

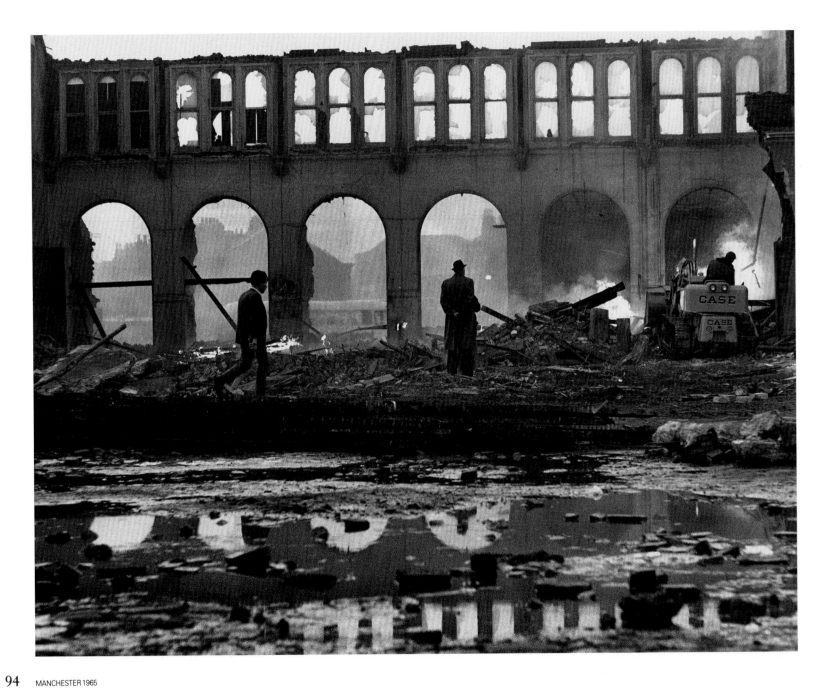

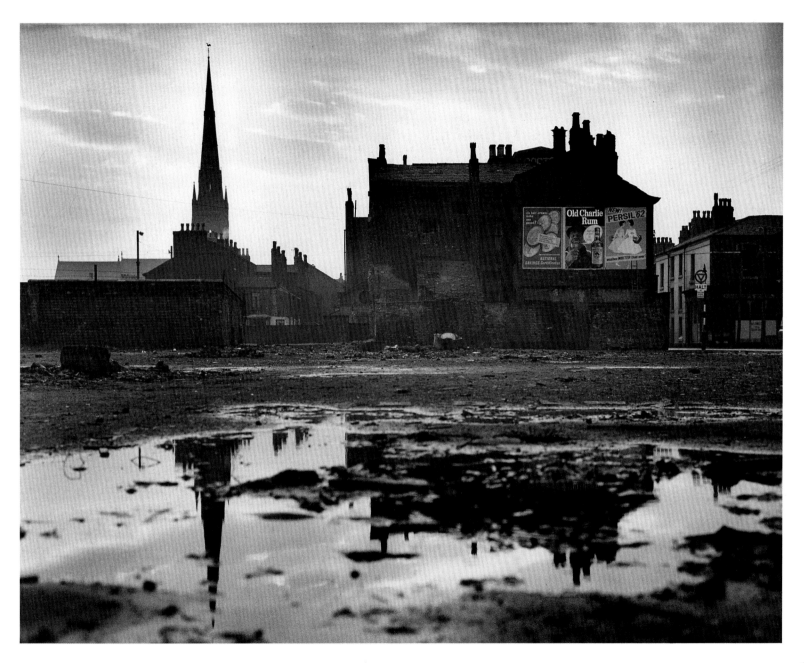

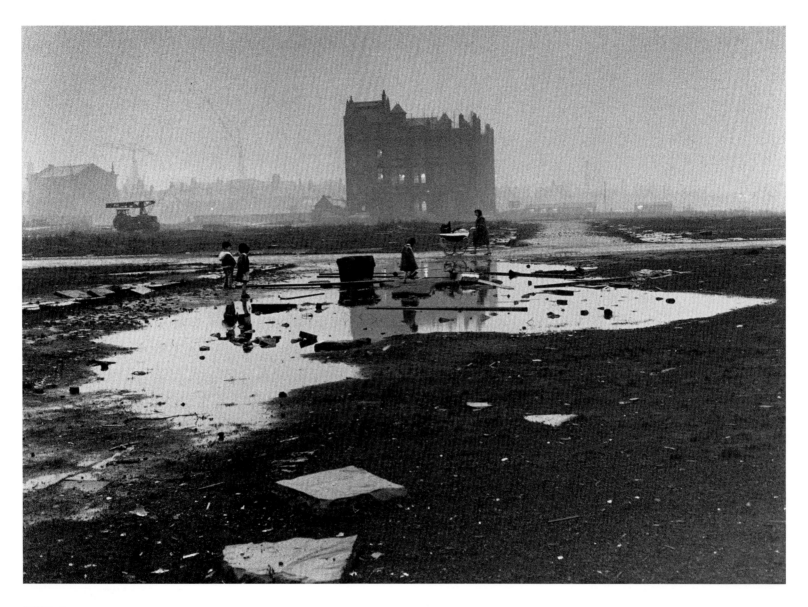

SALFORD 1964

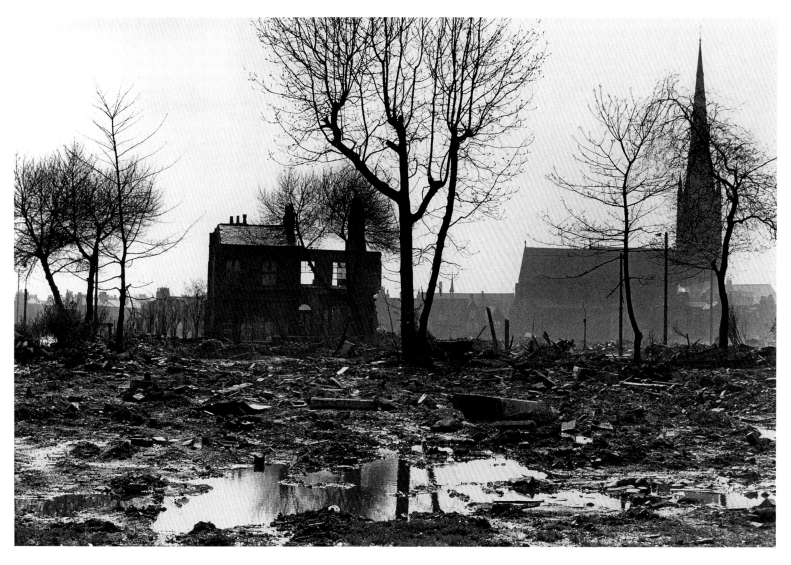

MANCHESTER 1966

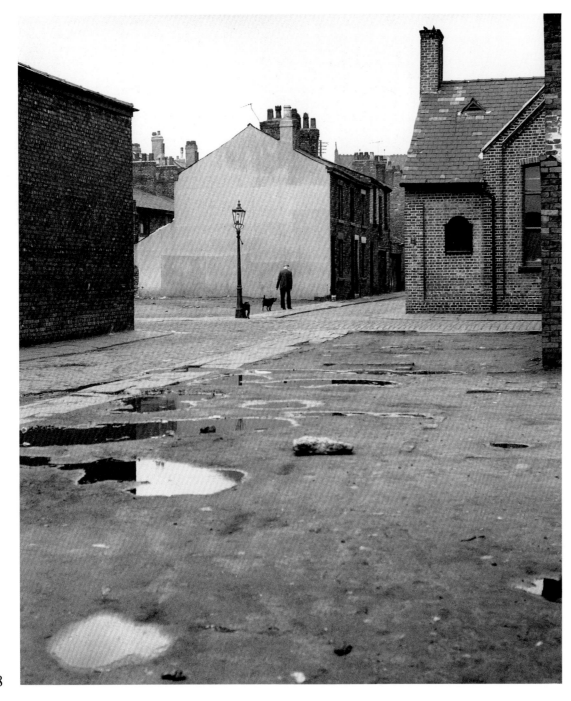

SALFORD 1962

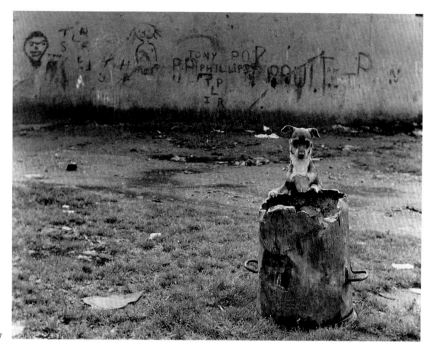

MANCHESTER 1967

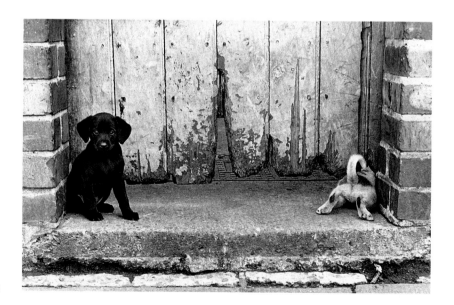

SALFORD 1964

99

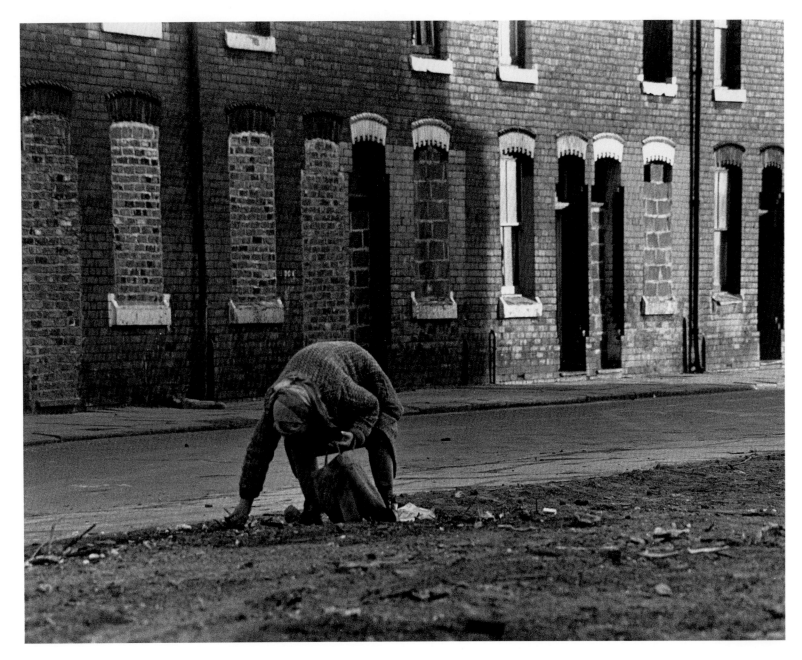

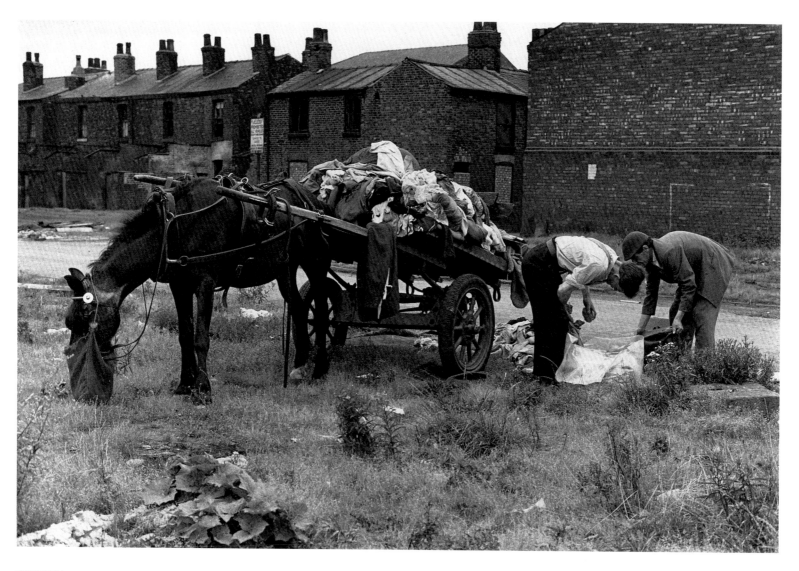

SALFORD 1964

101

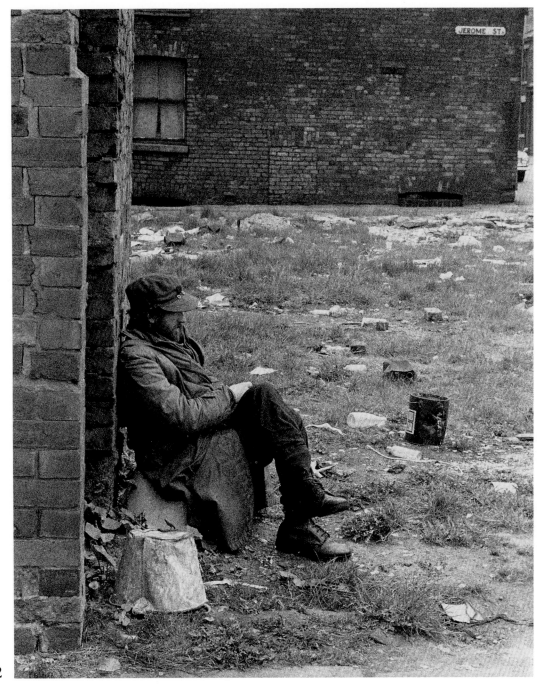

MANCHESTER 1965

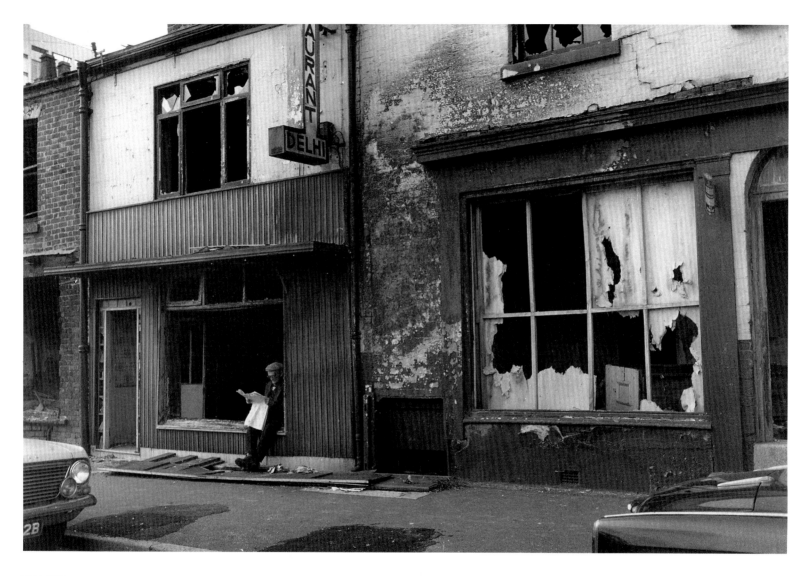

MANCHESTER 1968

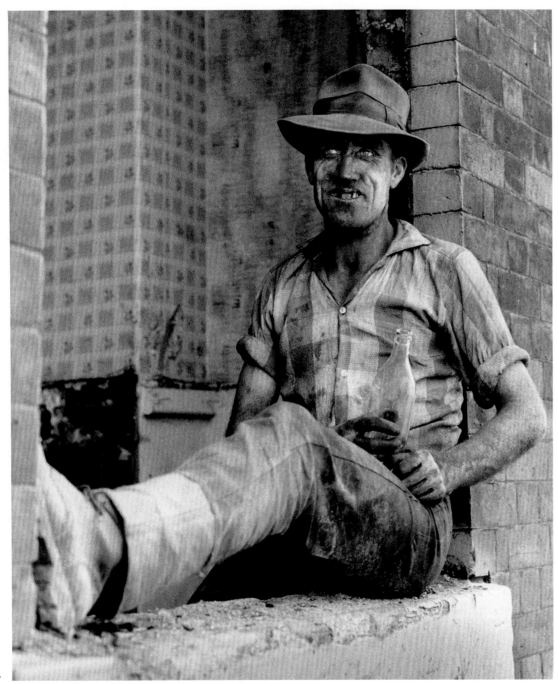

104

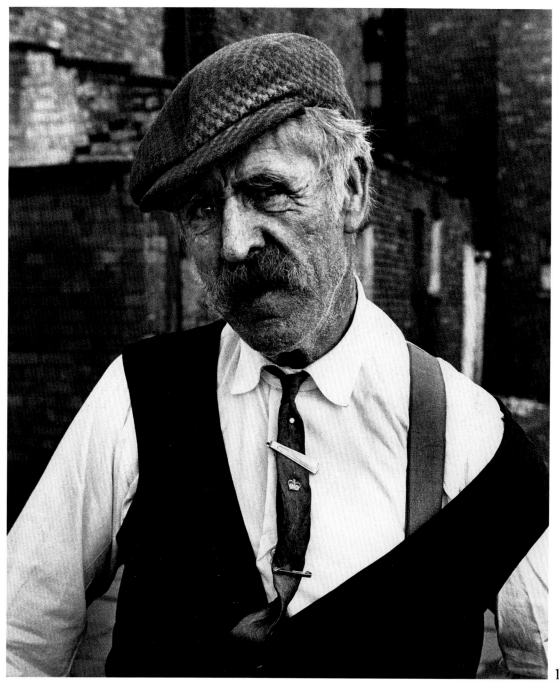

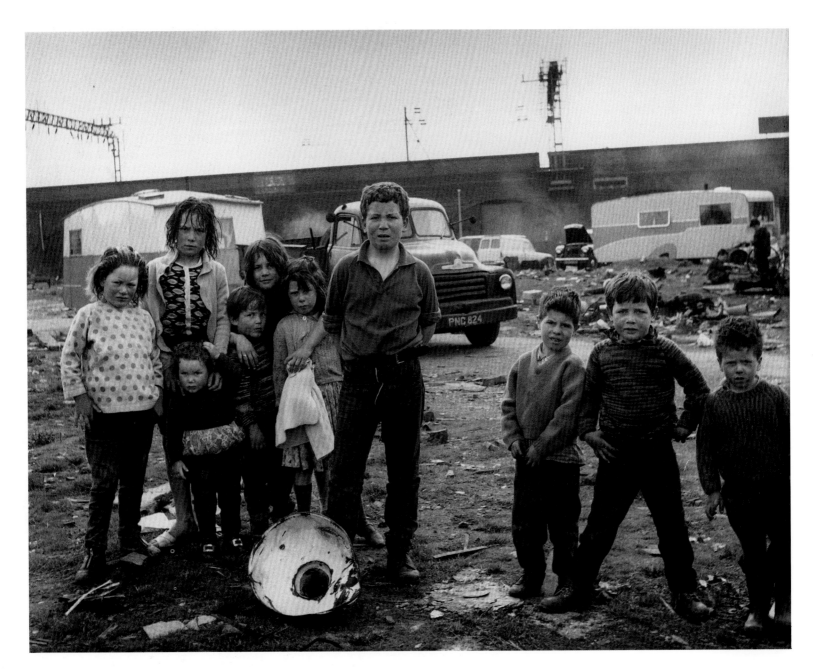

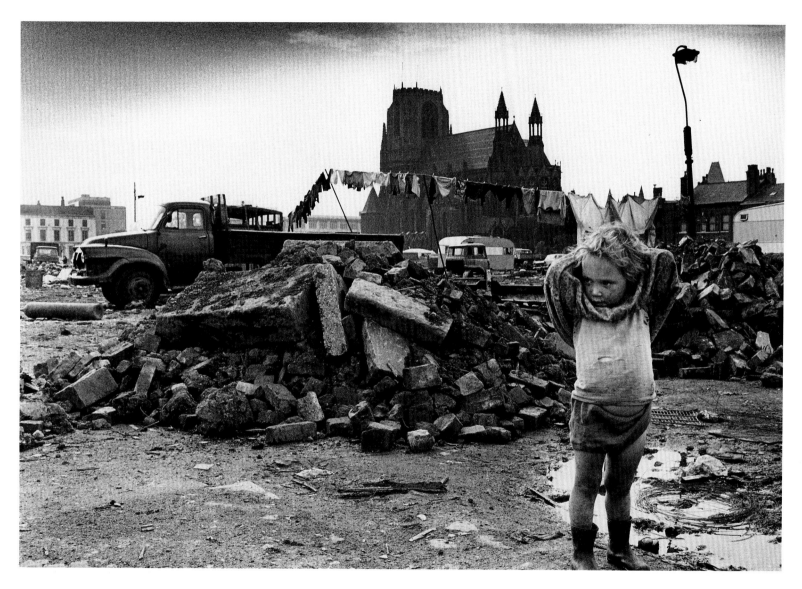

MANCHESTER UNIVERSITY 1968

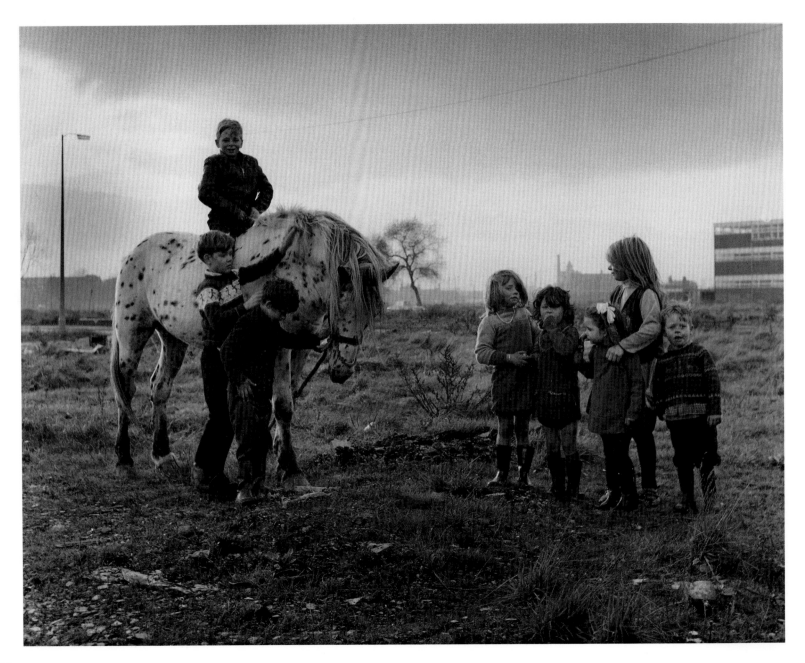

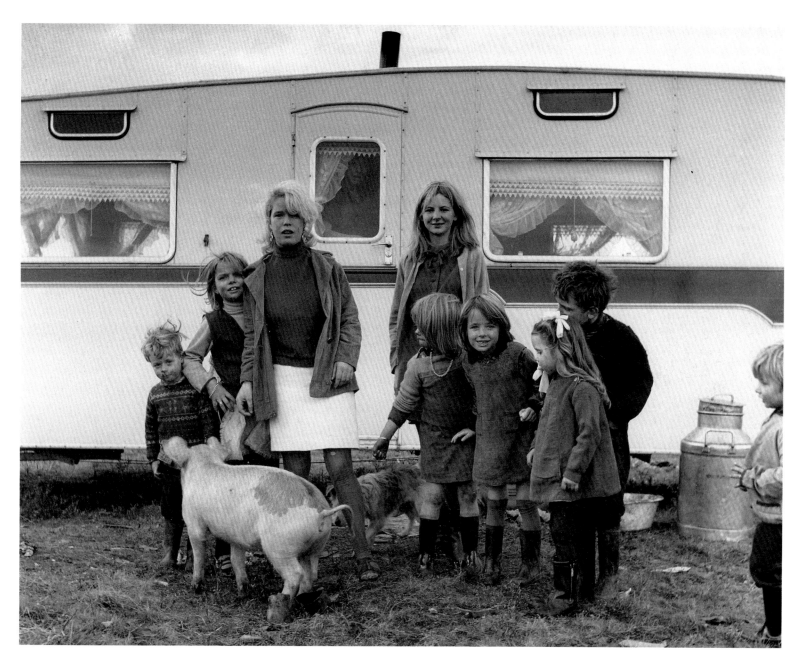

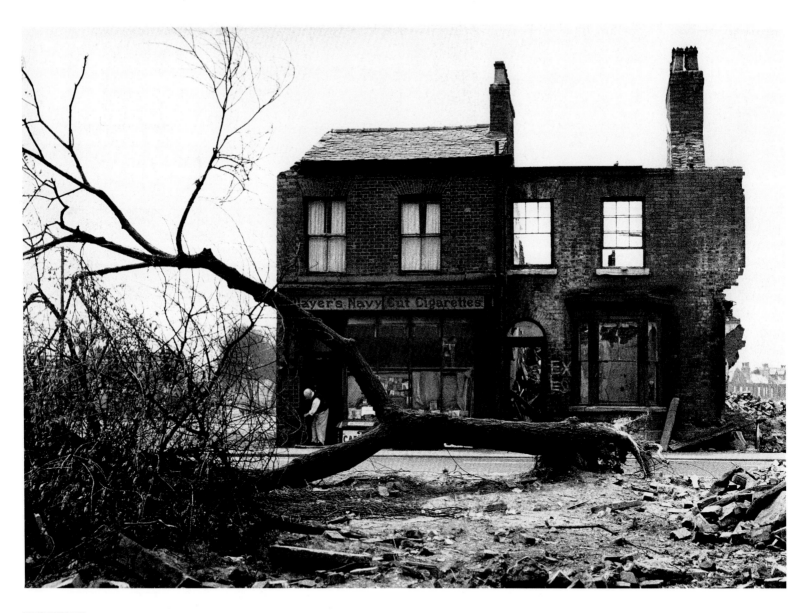

MANCHESTER 1966

110

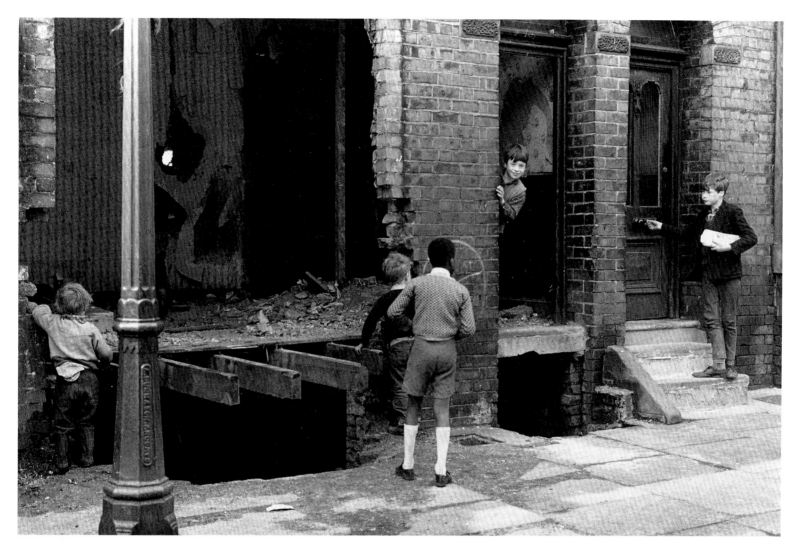

MANCHESTER 1966

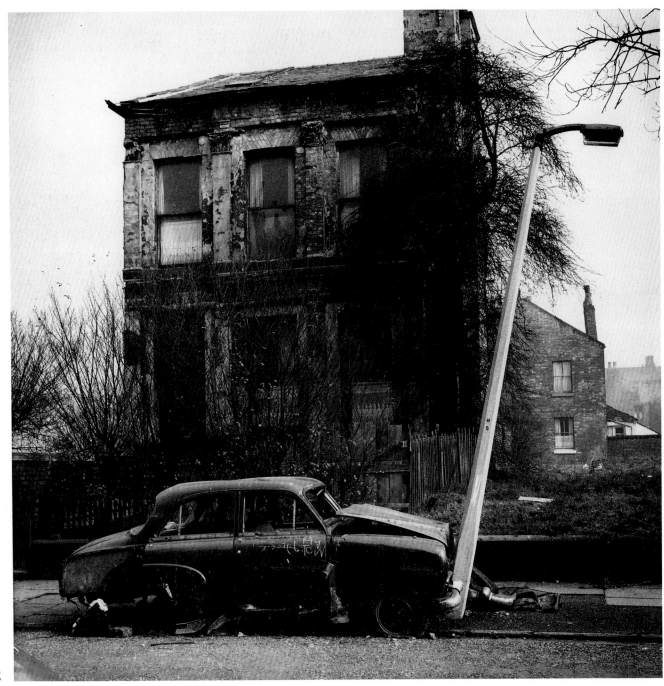

MANCHESTER 1966

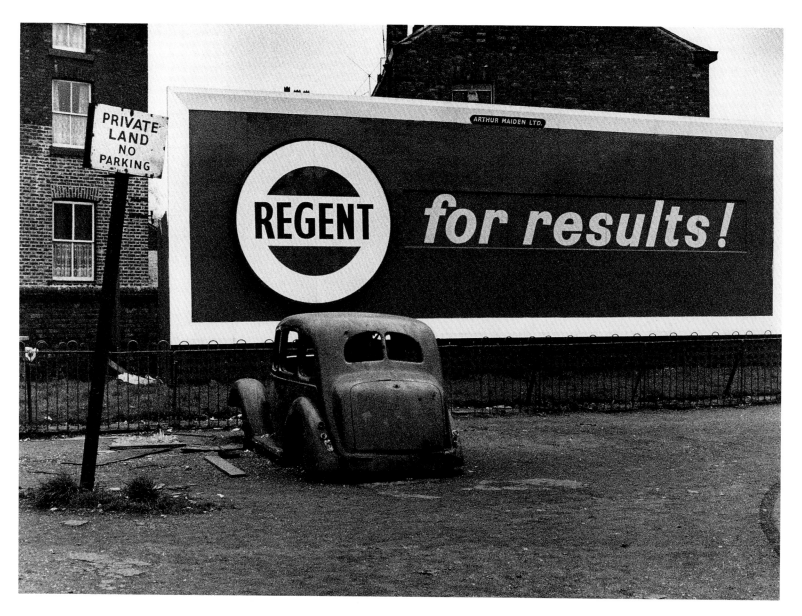

MANCHESTER 1964

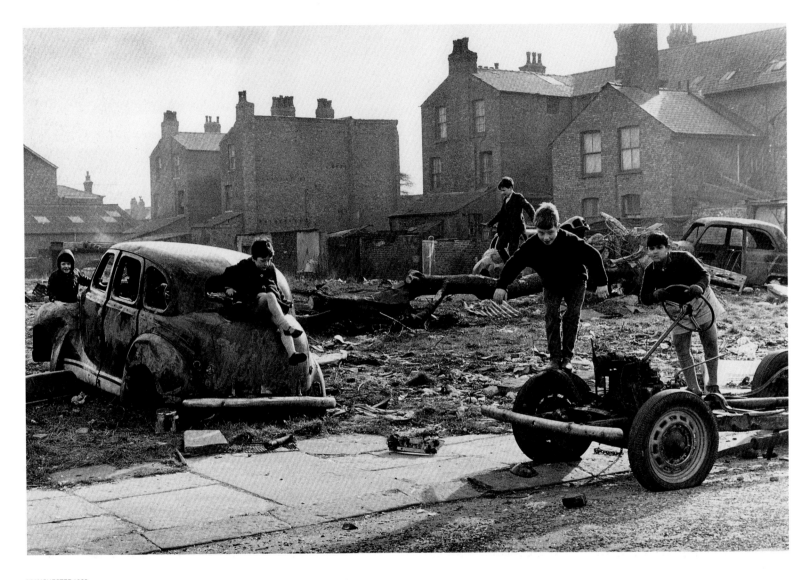

MANCHESTER 1968

114

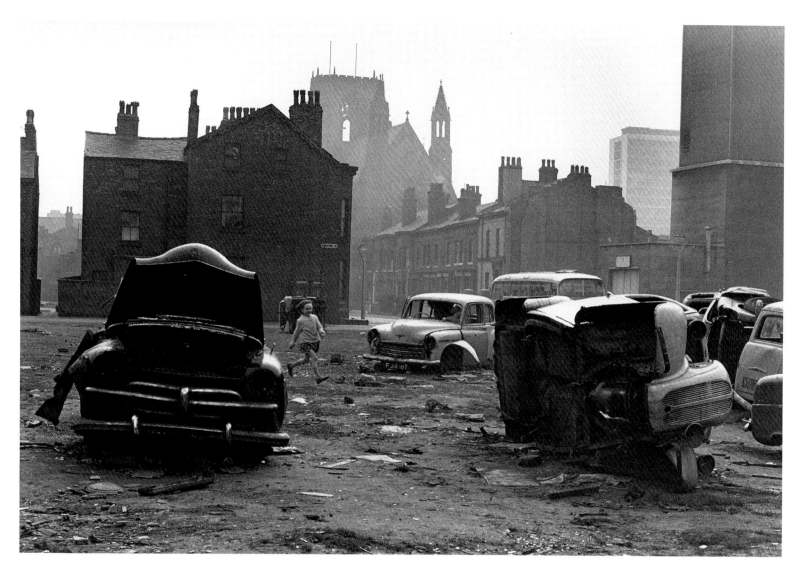

MANCHESTER 1965

115

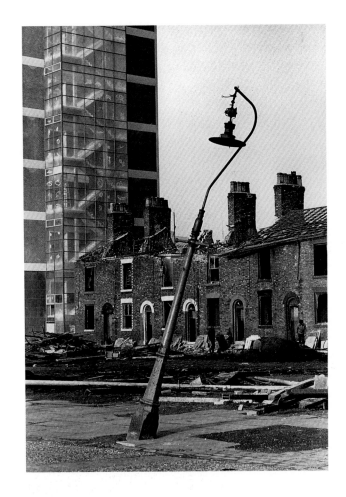

MANCHESTER 1964

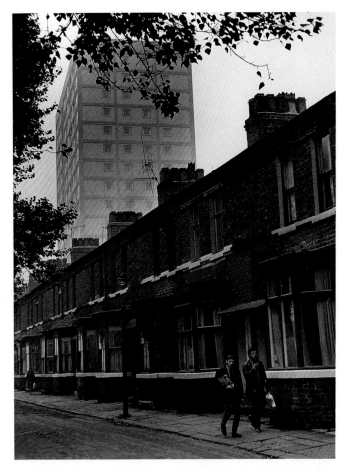

SALFORD 1970

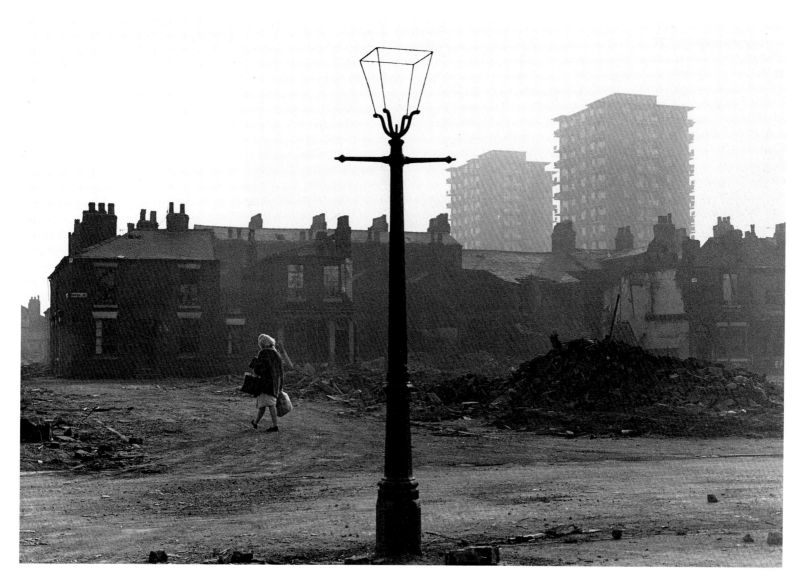

MANCHESTER 1965

117

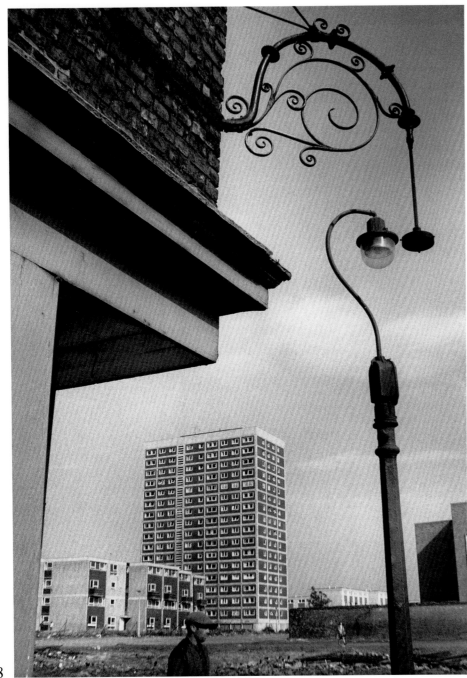

SALFORD 1966

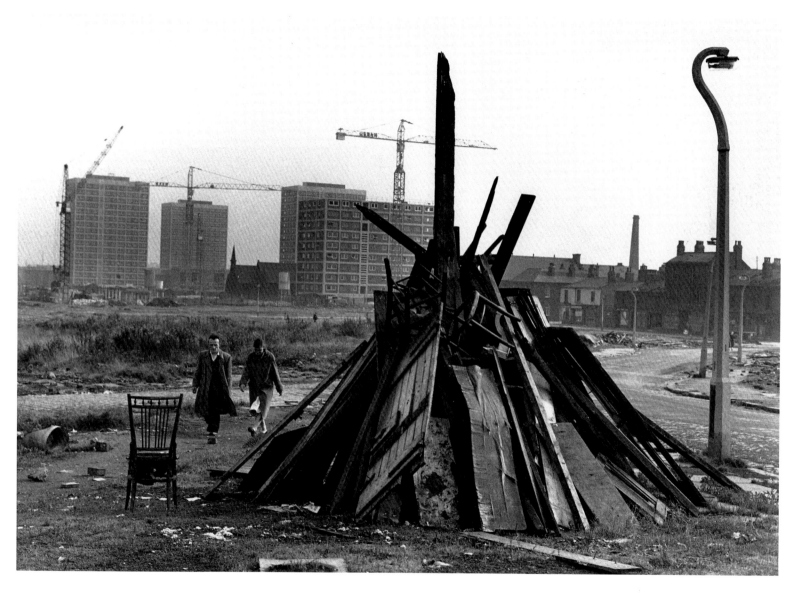

SALFORD 1965

119

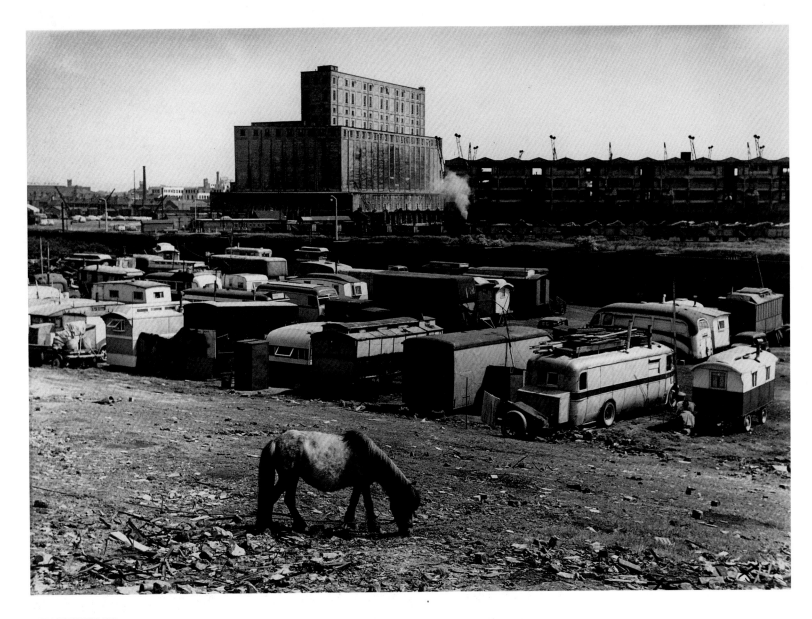

THE DOCKS, SALFORD 1960

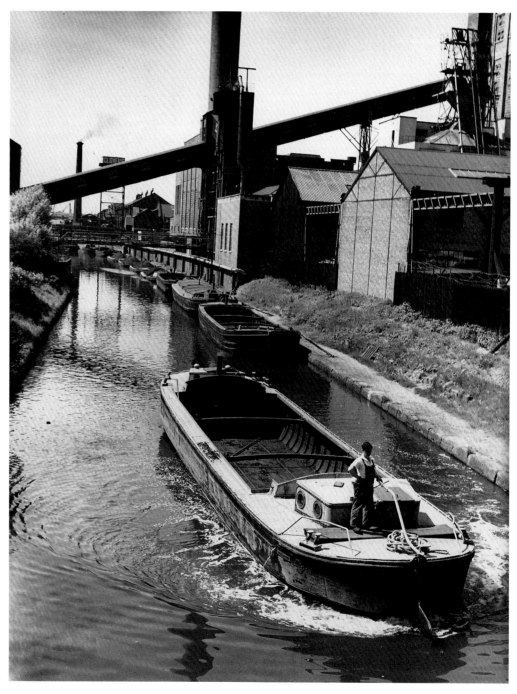

BRIDGEWATER CANAL, MANCHESTER 1960

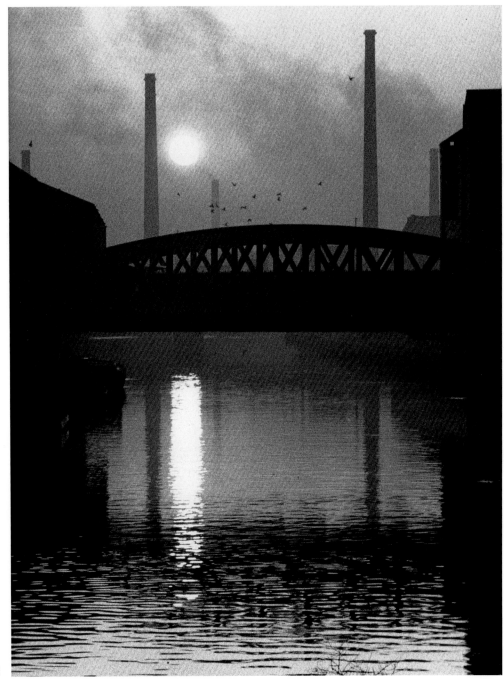

RIVER IRWELL, MANCHESTER 1966

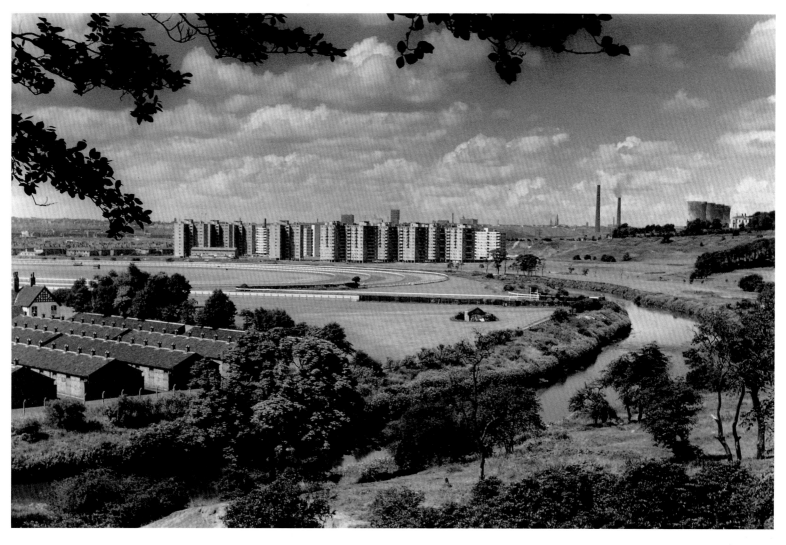

RIVER IRWELL, MANCHESTER RACECOURSE 1960

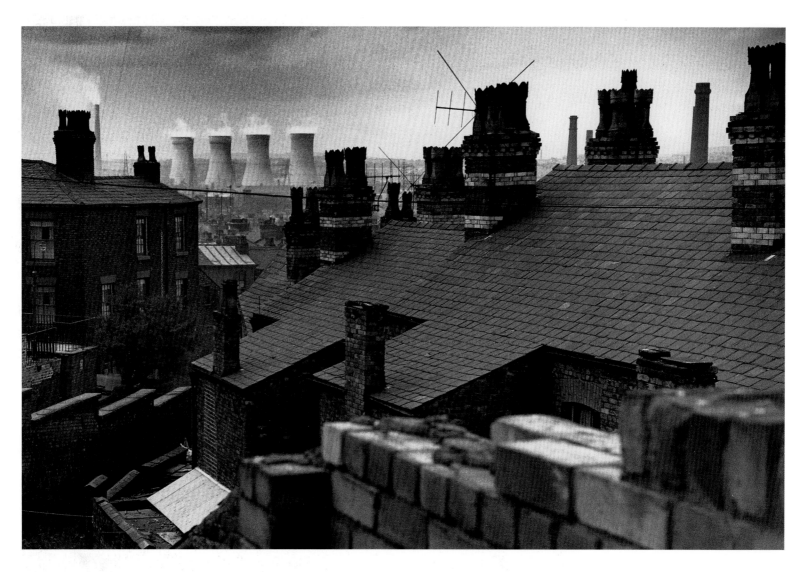

SALFORD 1962

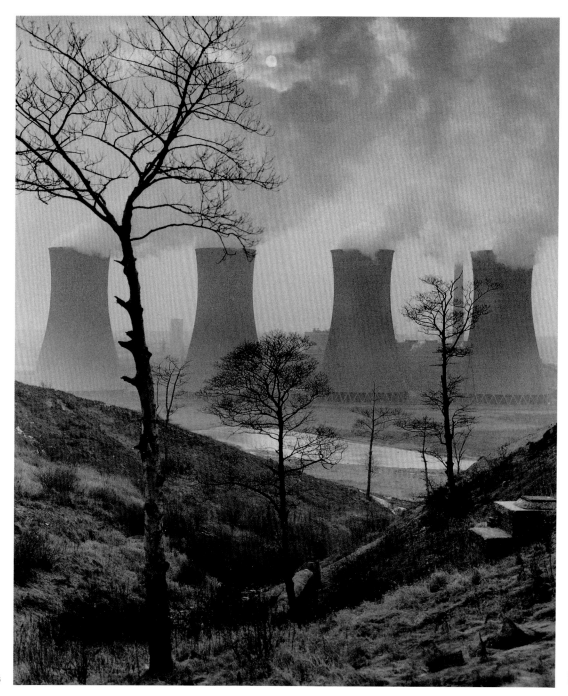

AGECROFT 1966

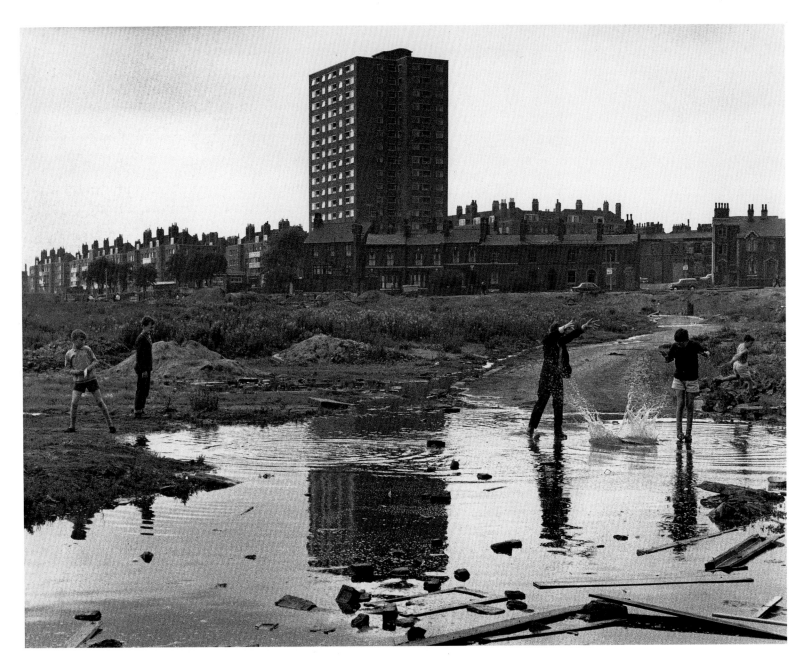

SALFORD 1966

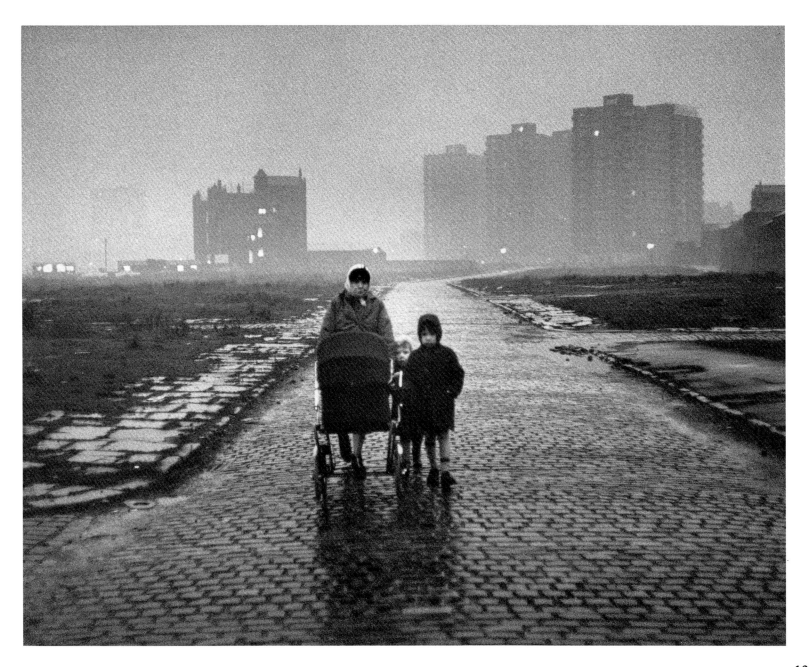

SALFORD 1964

Shirley Baker was born in Kersal, North Salford, and moved to Manchester at the age of two. Her father had a family furniture manufacturing business in Salford, but this no longer exists and the building has since been knocked down. She grew up in Manchester with a twin sister, and is now married with one daughter and lives in Cheshire.

She studied Pure Photography at Manchester College of Technology, and later took other courses at London Regent Street Polytechnic and London College of Printing. She has worked as an industrial photographer, as a freelance writer and photographer on magazines, books and newspapers, and as a lecturer at Salford College of Art and Manchester Polytechnic.

In 1986 her exhibition *Here Yesterday, and Gone Today* (featuring photographs now published in this book) was shown at Salford Art Gallery as part of the *Images of Salford* exhibition supported by the Documentary Photography Archive and North West Arts. She has shown work at other exhibitions in Manchester, and in 1986 had a touring exhibition, *My Face or Yours*, specially commissioned by Cheshire Arts Services and supported by North West Arts.

In 1987 she completed a project on the Royal Manchester Children's Hospital, supported by Viewpoint Gallery, Salford, and a Manchester Airport commission for the Documentary Photography Archive which was televised by Granada in their *Celebration* arts series.

Acknowledgements

My heartfelt thanks for their encouragement, help and trust to: Audrey Linkman, Caroline Warhurst, David Watt, Mike Lebur, Neil Wilkie, Dewi Lewis and Neil Astley. Thanks also to my family for accepting me at my nuisance value.

I am indebted to the Arts Council of Great Britain, North West Arts and the Documentary Photography Archive for their assistance, and am deeply grateful and always will be to Emanuel Rosen for his kindness in giving me the chance to take a second look. SB

Dr Stephen Constantine was brought up in Salford, and educated at Manchester Grammar School and the University of Oxford. Since 1971 he has taught at the University of Lancaster, where he is now Senior Lecturer in History.

His publications include *Unemployment in Britain between the Wars, Social Conditions in Britain 1918-1939, The Making of British Colonial Development Policy 1914-1940, Buy and Build: the Advertising Posters of the Empire Marketing Board* and several academic essays, including a study of *Love on the Dole* by the Salford novelist Walter Greenwood.

The **Documentary Photography Archive** exists to preserve for the future photographs and related materials which document the everyday life and experience of the people of the North West.

It initiates and tours exhibitions, produces books, publications and catalogues, promotes outside touring exhibitions in the region, and organises seminars, workshops and day schools. The DPA's collections are open to the public, and it provides an important resource of material for those who work in the fields of education, the media, publicity and publishing.

Shirley Baker's exhibition *Here Yesterday and Gone Today* is a DPA touring exhibition. It includes 40 of the photographs published in this book. The pictures are 20″ x 16″ prints, 30 in black and white and 10 in colour. The exhibition also includes introductory text mounted on card. A hire charge is levied, with insurance and transport the responsibility of the venue.

For further information about any aspect of the work of the DPA please contact: Documentary Photography Archive, c/o Cavendish Building, Cavendish Street, Manchester M15 6BG.